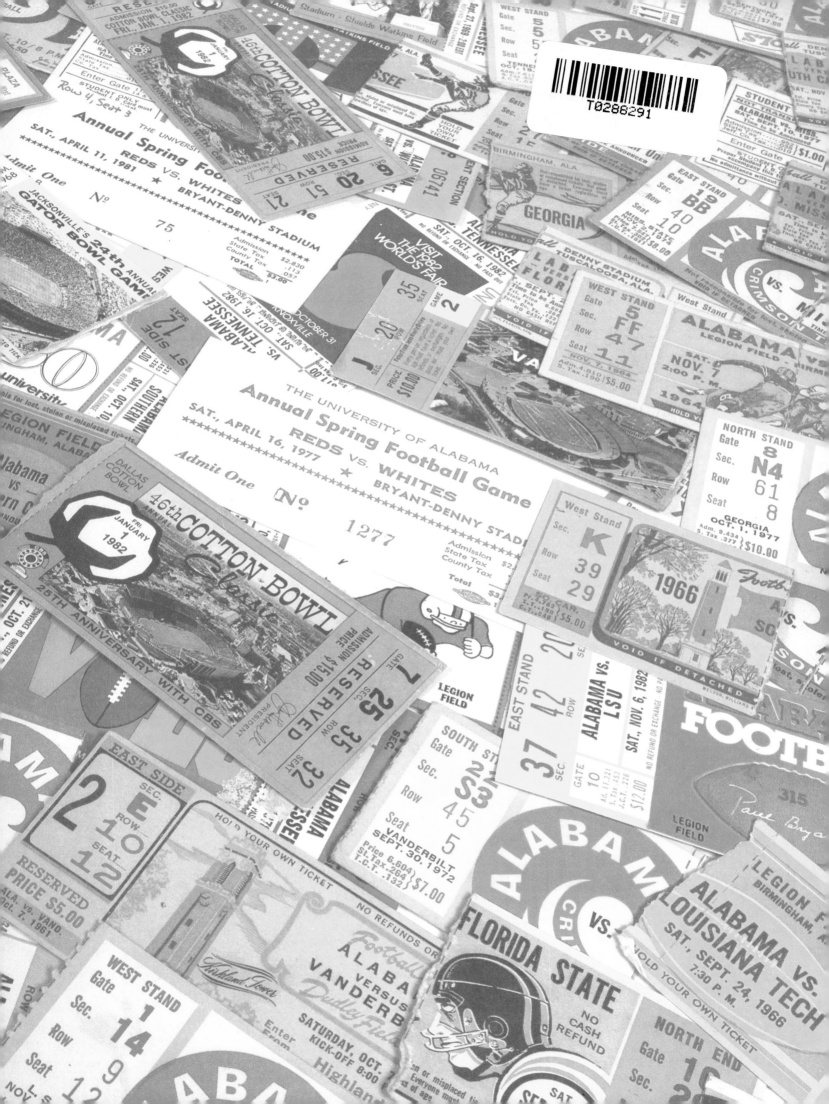

INSIDE THE VAULT

THE PAUL W. BRYANT COLLECTION

by TAYLOR WATSON | *Foreword by* KEN GADDY

PAUL W. BRYANT
CENTENNIAL CELEBRATION

1913 • 2013

ISBN 978-0-615-85214-0

Published by

300 Paul W Bryant Drive
Tuscaloosa, AL 35487
(205) 348-4668 • bryantmuseum.com

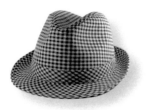

INSIDE THE VAULT

THE PAUL W. BRYANT COLLECTION

by TAYLOR WATSON | *Foreword by* KEN GADDY

Published by

THE PAUL W. BRYANT MUSEUM

VIDEO SUPPLEMENTS are provided via QR codes within the text of this publication. If you do not own a smartphone with scanning capabilities, please visit these URLs to access the videos.

bryantmuseum.com/aptrophy.mp4
bryantmuseum.com/wishbone.mp4
bryantmuseum.com/houndstoothhat.mp4
bryantmuseum.com/315.mp4
bryantmuseum.com/323.mp4

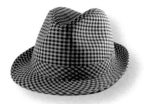

CONTENTS

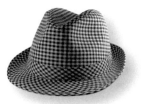

FOREWORD

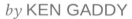

by KEN GADDY

Paul W. "Bear" Bryant is a legend. His lists of accomplishments on and off the field are almost too long to recite. Bryant earned six national championships as head coach at The University of Alabama and another as a player at Bama. Bryant was named national coach of the year three times during his 38 seasons as a head coach. His Crimson Tide teams won 13 SEC crowns while Bryant collected ten SEC coach of the year awards during his 25 years at the helm of the Tide.

So many people contributed to Inside the Vault: The Paul W. Bryant Collection. The staff of the Bryant Museum as always was vital to the process. Taylor Watson and Brad Green of our collections department did yeoman's work researching the collection for items to be considered for inclusion and Taylor made the tough final decisions. Olivia Arnold made sure we kept the budget in line and the production schedule on time. Many of our students contributed, and one in particular, John Stephens, left his mark on the book.

Teresa Golson is the photographer responsible for the fantastic images you are about to enjoy on the following pages. The book design is by the talented Laura Lineberry. I want to thank the fans of the University of Alabama and the supporters of the Paul W. Bryant Museum. Many of these treasures are donated by fans and their contribution to this book is greatly appreciated. Lastly, I want to thank the Bryant family for sharing Coach Bryant with us.

Roll Tide!

.

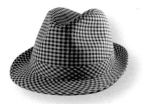

THE EARLY DAYS

1913–1944

FORDYCE REDBUGS OF NINETEEN-THIRTY

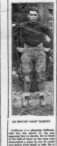
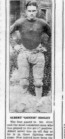
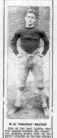
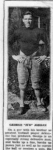

The record established by the 1930 Fordyce High School football squad, pictured here, is one of which any city might be proud. It is a record the memory of which cannot be erased by the passing years; one that will be remembered in the years to come by fans and players alike. Not only will this 1930 team be remembered for it's victories on the field of battle, but also for the clean sportsmanship of each individual player, which, when taken as a whole, reflect great credit upon their home town and their school. Coming generations of Fordyce football men will look back upon the 1930 team as an example to follow--an example to emulate and to strive to excel. Future teams will be guaged by this great machine of 1930. Not only have these sturdy boys brought honor to their school, for the city of Fordyce itself is honored in being the home of a team heralded far and wide as the greatest to come out of any Arkansas community. From border to border of the state praise for the 1930 Redbugs is being sung by thousands and thousands of fans, admirers of the clean, upstanding boys who, by their great team-work, have written football history for Arkansas. The prowess of the team has even attracted the attention of some of the nation's greatest schools and it will not be surprising to see the names of some of our 1930 squad written in the nation's Hall of Fame, along with other great gridiron warriors. Fordyce is indeed proud of her 1930 Redbugs. Proud to be the home of the team that has won the applause of tens of thousands of fans, who have been converted into friends by the thoroughly efficient manner in which they "played the game." The undersigned join in extending this tribute of praise to "The Team" and to the coach, for what they have done for their school and their home town--Fordyce. And here on the eve of the 1930 season, every member of "The Team" is extended the congratulations of the entire community, with a wish that when high school days are over and they go to battle in the game of life, that the same spirit that carried them to victory on the field of sport may guide them to greater victory out yonder.

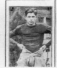
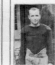

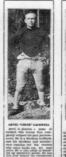
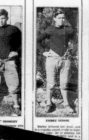

FORDYCE REDBUGS POSTER, 1930

A POST CARD FROM A FORDYCE ARKANSAS BUSINESS, CIRCA 1930

PAUL "BEAR" BRYANT

Paul is all that his nick-name implies. He is a bear at football, and is one of the most spectacular tackles in the game. His hard smashing charge through the line breaks up many a play for the opposition. At offensive end he is showing great ability and well deserves the position of all-state tackle, which he won last season.

THE BEGINNING

Paul Bryant was born September 11, 1913 on farm land, called Moro Bottom in rural Arkansas. Paul, one of 12 kids to Ida Mae and Monroe Bryant, grew up in a four room house with no electricity or running water. The Bryant's worked a 260 acre vegetable farm that fed the Bryant clan with enough left over to sell to the city folk of Fordyce. The daily work of farm life made Paul into a football player. Strong, tough, not scared of hard work, or sweat, Paul was perfect for the game.

"I have said it many a time, I do love football. I really do. Lord knows where I'd be without it. Probably back in Arkansas pushing a plow."

— *Coach Bryant*

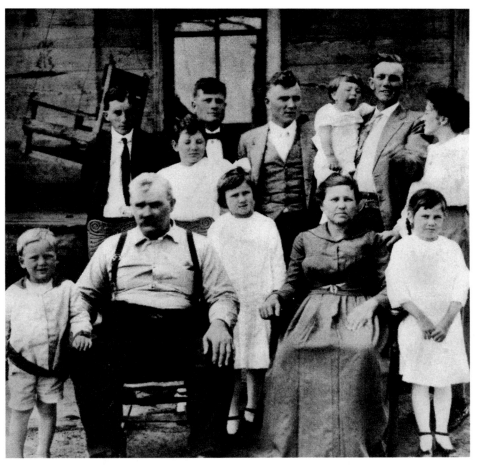

BRYANT FAMILY PORTRAIT, CIRCA 1915

THE LEGEND BEGINS

The summer before his 8th grade year, Paul and some friends walked the seven miles into Fordyce to see a movie. When Bryant and his friends got to the theater they noticed a poster on the door announcing a curious pre-movie event; "One dollar per minute for anyone who'll wrestle the bear."

When the man that agreed to wrestle the bear didn't show, Paul, realizing a dollar a minute could be a gold mine, made the deal. After only a few seconds the bear's muzzle had worked loose, and Paul grasped he was in danger and leaped off the stage. He never got paid, but his friends would give him a prize much greater than a dollar, a nickname that would last a lifetime, "Bear."

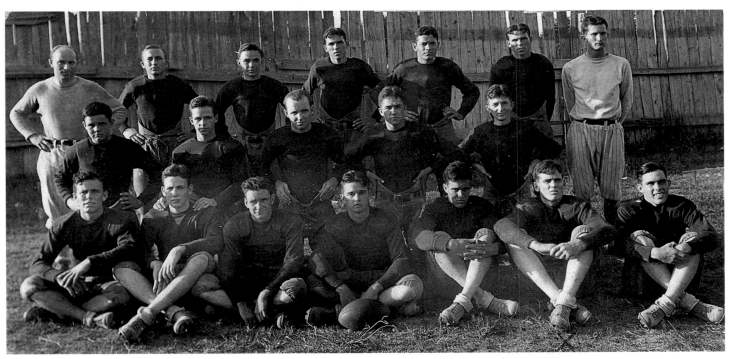

1930 FORDYCE REDBUGS, BRYANT 1ST ROW, 2ND FROM RIGHT

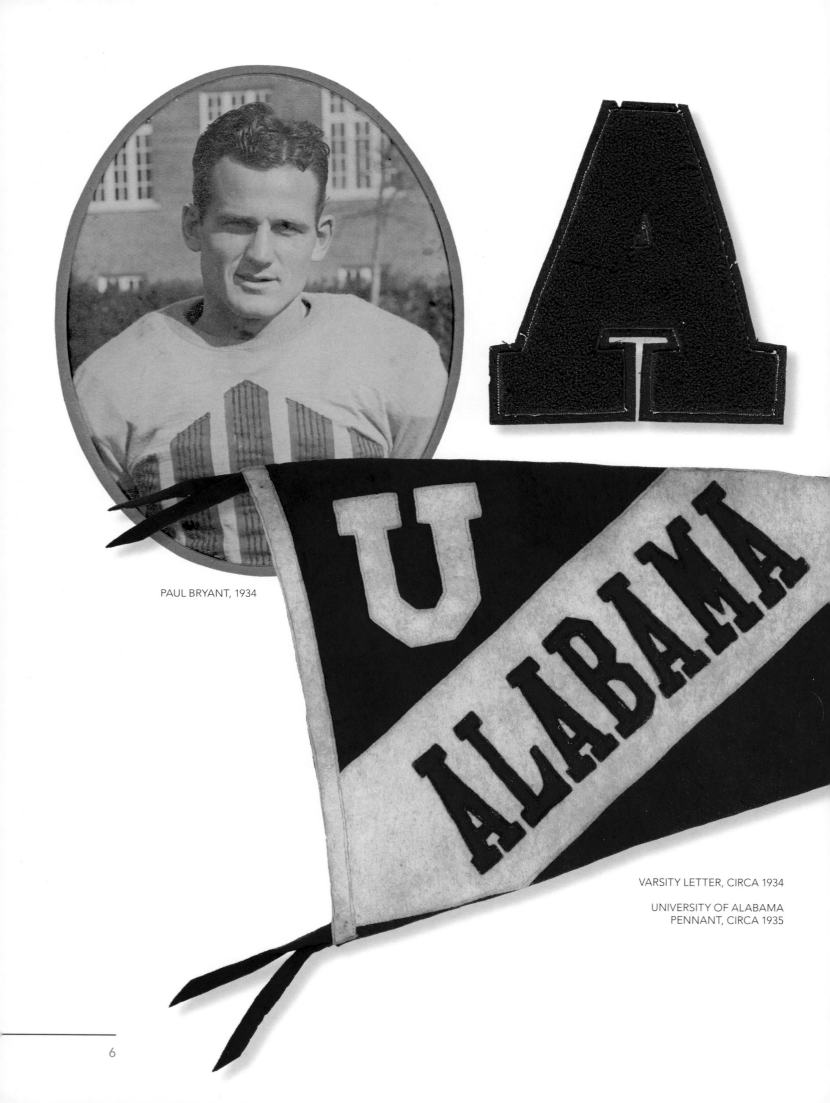

PAUL BRYANT, 1934

VARSITY LETTER, CIRCA 1934

UNIVERSITY OF ALABAMA
PENNANT, CIRCA 1935

THE OTHER END

Paul Bryant arrived on campus in the summer of 1931. He spent his first year working hard on the practice squad. All of his patience and hard work paid off when he earned a spot as an offensive end and defensive tackle on the varsity team. Bryant made himself into a good player, but when he was playing opposite Don Hutson, Bryant would always be known as the other end. Don Hutson, also a native of Arkansas, was a spectacular player, earning All-America honors in 1934 while helping the Tide to another national championship. After his Alabama days, Hutson went on to become one of pro football's all-time greats with the Green Bay Packers.

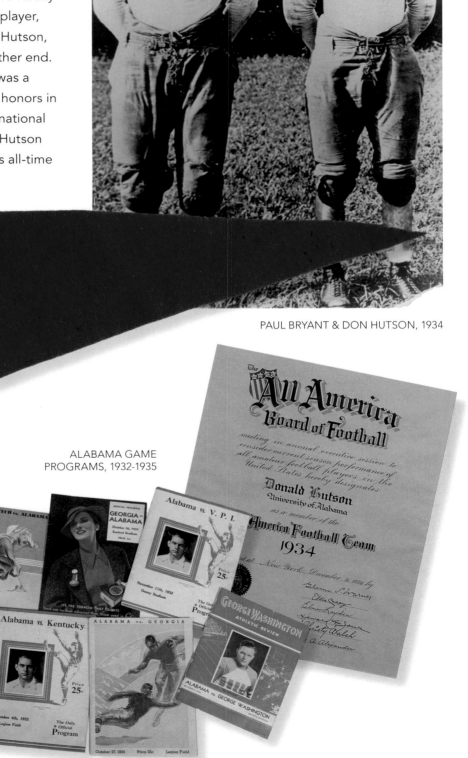

PAUL BRYANT & DON HUTSON, 1934

ALABAMA GAME
PROGRAMS, 1932-1935

ROSE BOWL PROGRAM, 1935

OPPOSITE PAGE INSIDE ROSTER FROM
ROSE BOWL PROGRAM, 1935

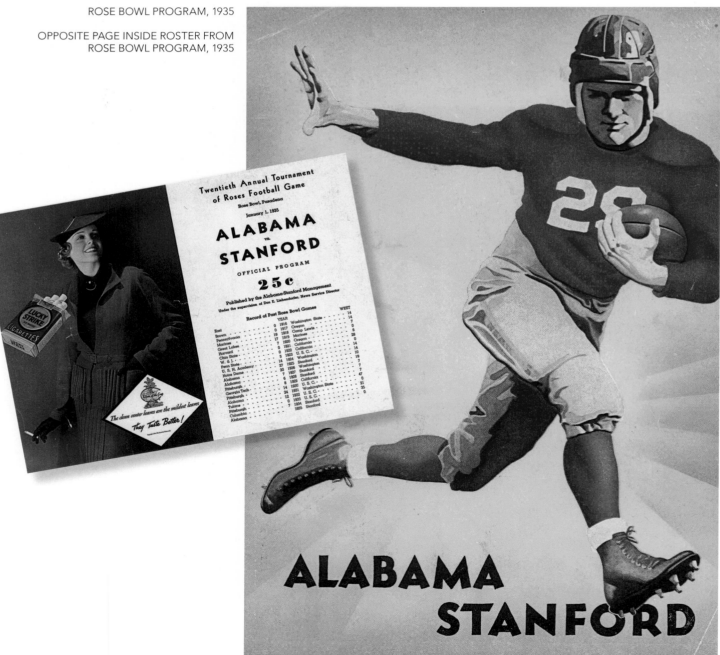

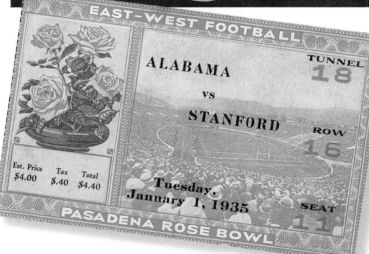

"That 1934 team was my greatest.

It had what it took."

— *Frank Thomas*

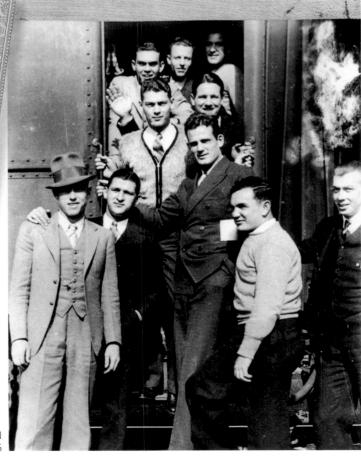

ALABAMA PLAYERS ON
ROSE BOWL TRIP, 1935

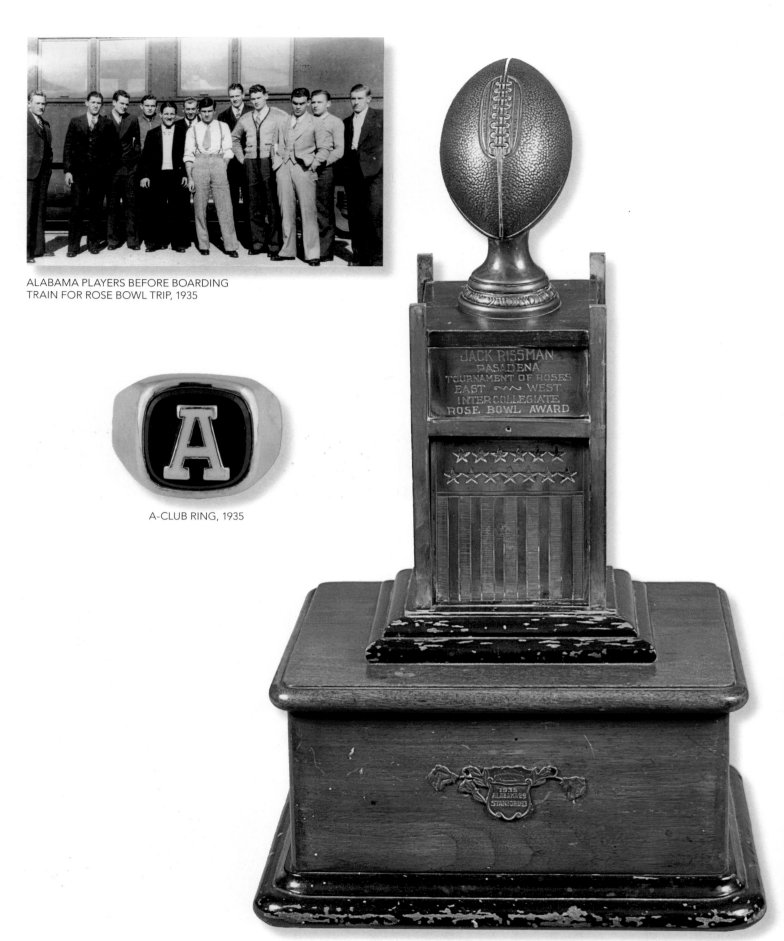

ALABAMA PLAYERS BEFORE BOARDING
TRAIN FOR ROSE BOWL TRIP, 1935

A-CLUB RING, 1935

JACK RISSMAN
PASADENA
TOURNAMENT OF ROSES
EAST ~~ WEST
INTERCOLLEGIATE
ROSE BOWL AWARD

ROSE BOWL TROPHY, 1935

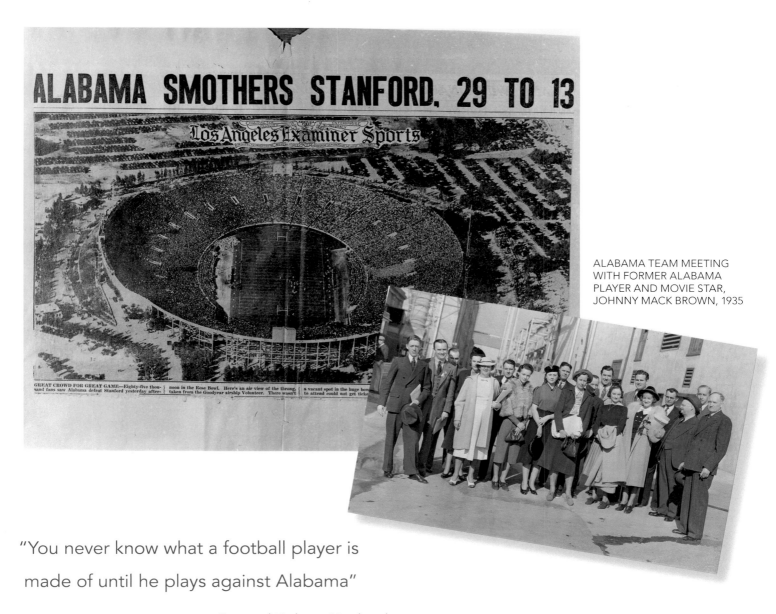

ALABAMA SMOTHERS STANFORD, 29 TO 13

Los Angeles Examiner Sports

GREAT CROWD FOR GREAT GAME—Eighty-five thou- | noon in the Rose Bowl. Here's an air view of the throng, | a vacant spot in the huge bowl
sand fans saw Alabama defeat Stanford yesterday after- | taken from the Goodyear airship Volunteer. There wasn't | to attend could not get ticke

ALABAMA TEAM MEETING
WITH FORMER ALABAMA
PLAYER AND MOVIE STAR,
JOHNNY MACK BROWN, 1935

"You never know what a football player is
made of until he plays against Alabama"

— *General Robert Neyland*

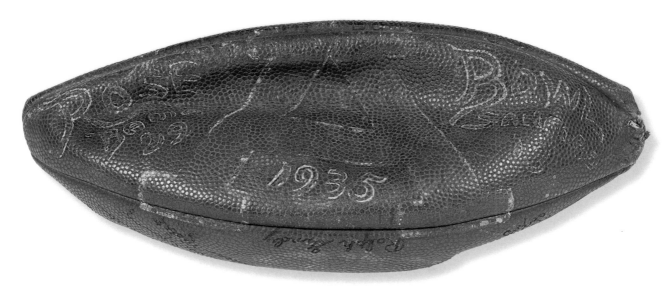

ROSE BOWL FOOTBALL, 1935

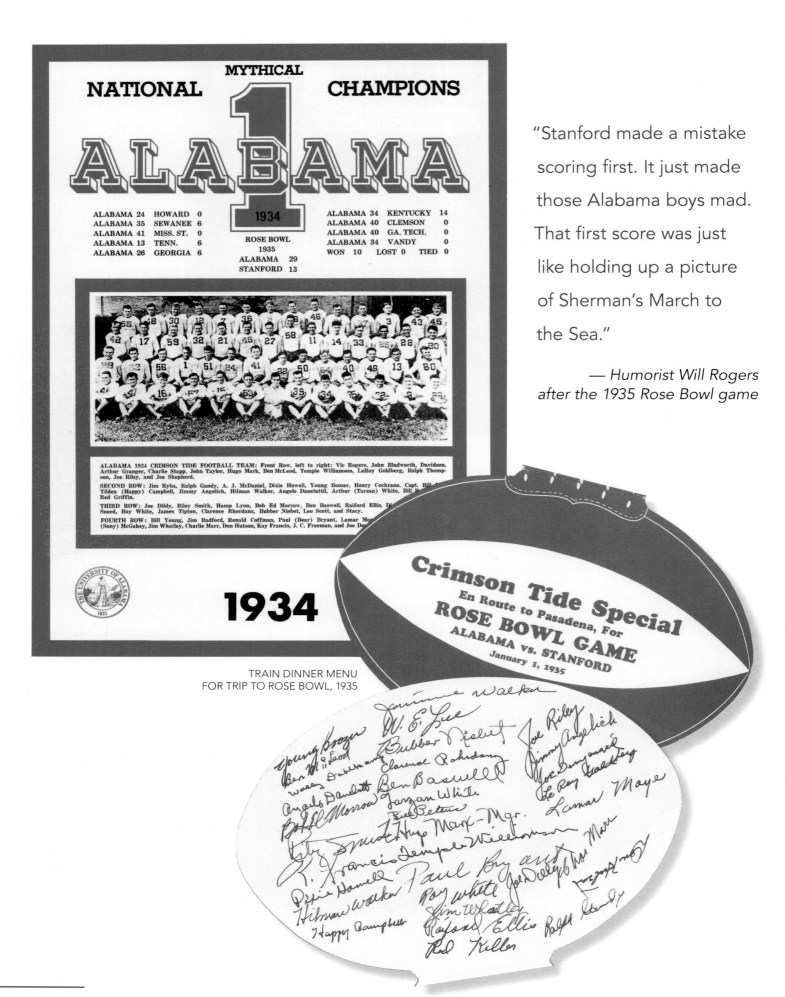

MYTHICAL
NATIONAL CHAMPIONS

ALABAMA

1
1934

ALABAMA 24	HOWARD 0		ALABAMA 34	KENTUCKY	14
ALABAMA 35	SEWANEE 6		ALABAMA 40	CLEMSON	0
ALABAMA 41	MISS. ST. 0		ALABAMA 40	GA. TECH.	0
ALABAMA 13	TENN. 6		ALABAMA 34	VANDY	0
ALABAMA 26	GEORGIA 6		WON 10	LOST 0	TIED 0

ROSE BOWL
1935
ALABAMA 29
STANFORD 13

ALABAMA 1934 CRIMSON TIDE FOOTBALL TEAM: Front Row, left to right: Vic Rogers, John Bludworth, Davidson, Arthur Granger, Charlie Stapp, John Taylor, Hugo Mark, Ben McLeod, Temple Williamson, LeRoy Goldberg, Ralph Thompson, Joe Riley, and Joe Shepherd.

SECOND ROW: Jim Ryba, Ralph Gandy, A. J. McDaniel, Dixie Howell, Young Boozer, Henry Cochrane, Capt. Bill [...] Tilden (Happy) Campbell, Jimmy Angelich, Hilman Walker, Angelo Daneluttil, Arthur (Tarzan) White, Bill P[...] Red Griffin.

THIRD ROW: Joe Dildy, Riley Smith, Hamp Lyon, Bob Ed Morrow, Ben Baswell, Raiford Ellis, Di[...] Sneed, Roy White, James Tipton, Clarence Rhordanz, Bubber Nisbet, Leo Scott, and Stacy.

FOURTH ROW: Bill Young, Jim Radford, Ronald Coffman, Paul (Bear) Bryant, Lamar Mo[...] (Sony) McGahey, Jim Whatley, Charlie Marr, Don Hutson, Kay Francis, J. C. Freeman, and Joe De[...]

1934

TRAIN DINNER MENU
FOR TRIP TO ROSE BOWL, 1935

Crimson Tide Special
En Route to Pasadena, For
ROSE BOWL GAME
ALABAMA vs. STANFORD
January 1, 1935

"Stanford made a mistake scoring first. It just made those Alabama boys mad. That first score was just like holding up a picture of Sherman's March to the Sea."

— *Humorist Will Rogers after the 1935 Rose Bowl game*

MARY HARMON BLACK

Mary Harmon Black, of Troy, Ala., and Paul W. Bryant were college sweethearts, Bryant the rugged football player, Mary Harmon the beauty queen. The two married right after college in June of 1935.

Mary Harmon never coached a down, but she worked just as hard, almost always out of the limelight, as Coach Bryant. During their life together she became a substitute mother for hundreds of young men who were far away from both their homes and their mothers.

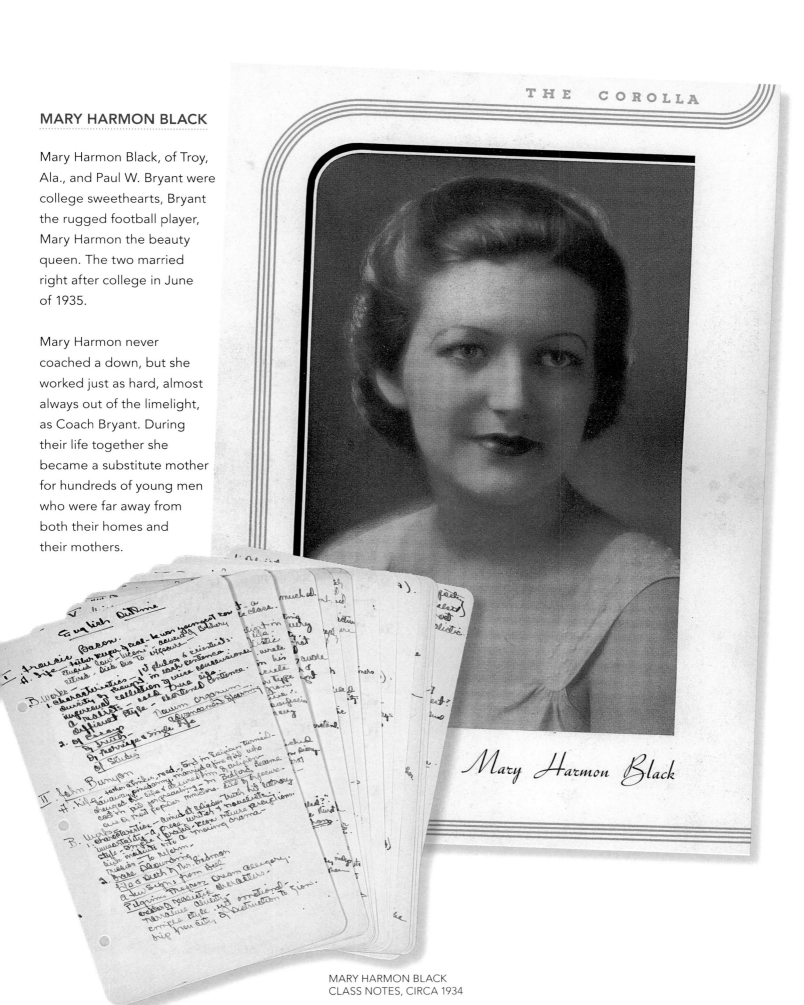

Mary Harmon Black

MARY HARMON BLACK
CLASS NOTES, CIRCA 1934

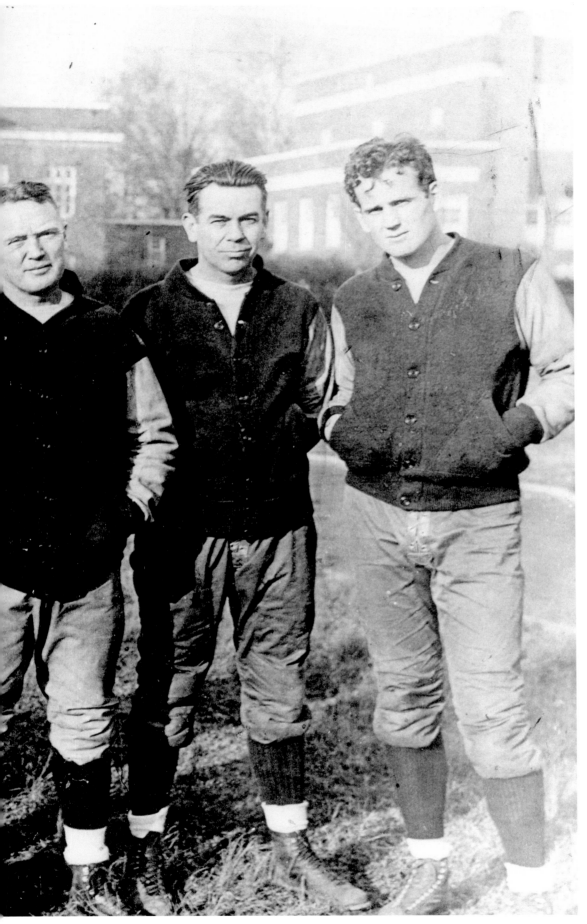

LEARNING TO COACH

All great individuals get help along the way, including Coach Bryant. On numerous occasions Bryant spoke of his many mentors, especially Frank Thomas, Hank Crisp, and his high school coach Robert Cowan. Frank Thomas, (who learned the game under the great Notre Dame coach Knutne Rockne) saw the coaching potential when Bryant was still a player.

UNIVERSITY OF ALABAMA COACHING STAFF, 1938

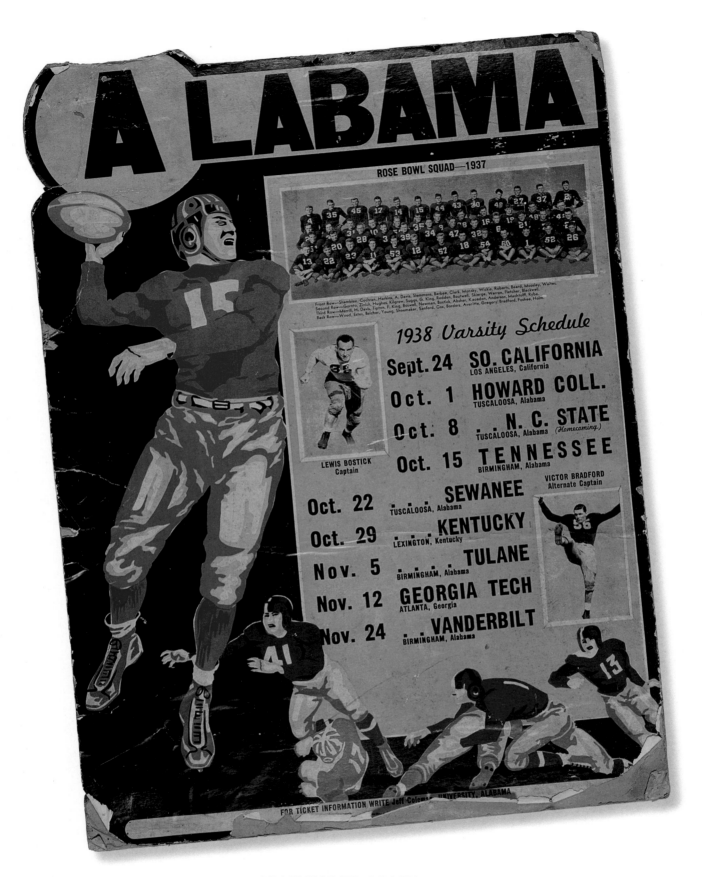

LEARNING TO COACH

After Bryant's senior year, Thomas offered Bryant an assistant coaching job on his staff; Bryant accepted. His first position earned him $1,250 a year as assistant coach and his primary assignment was recruiting players. With Thomas' offer, player Bryant became Coach Bryant and on his way to the record books.

HOTEL VISTA DEL ARROYO DINNER MENU
FROM TEAM VISIT DURING ROSE BOWL TRIP, 1938

New Year's Day
Dinner

1938

ALABAMA vs.
NORTH CAROLINA STATE

HOMECOMING
OCTOBER 8, 1938
DENNY STADIUM

ALABAMA VS. VANDERBILT PROGRAM ROSTER PAGE, 1940

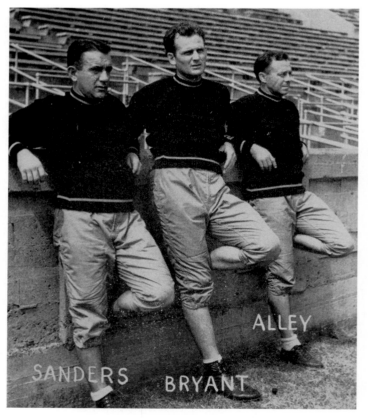

VANDERBILT COACHING
STAFF, 1940

DESTINY

After successful assistant coaching jobs at Alabama and Vanderbilt; Coach Bryant applied for the head coaching job at the University of Arkansas. After four interviews Bryant was confident the job was his, but destiny stepped in the way. For Bryant, destiny came in the form of December 7, 1941. Bryant volunteered the next day.

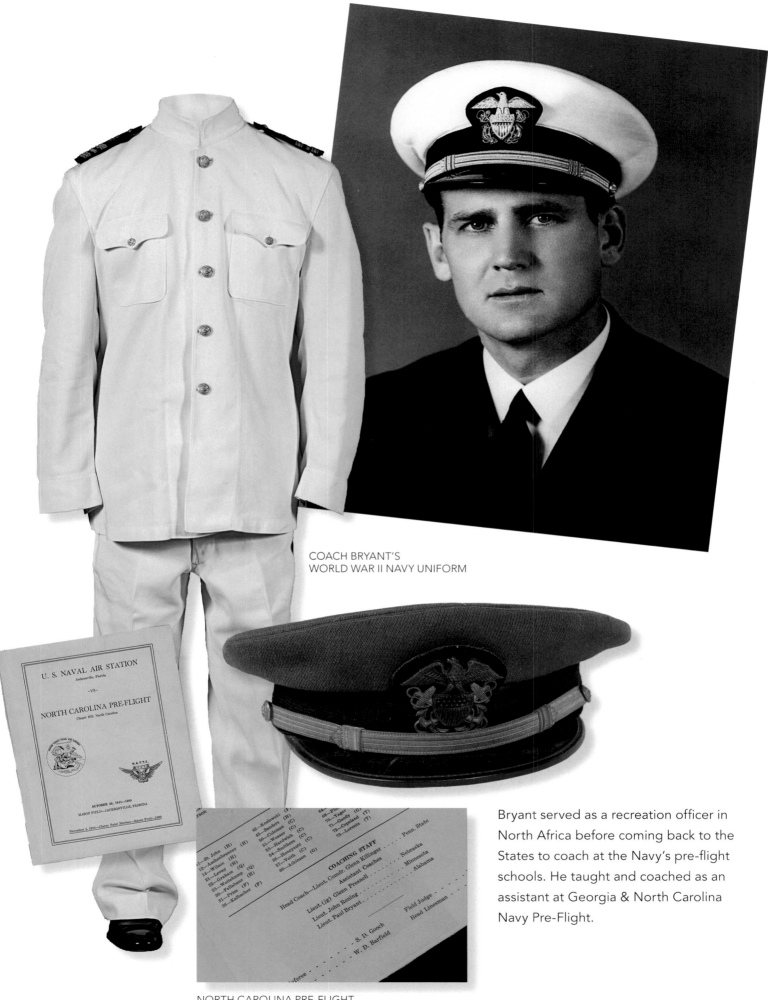

COACH BRYANT'S
WORLD WAR II NAVY UNIFORM

Bryant served as a recreation officer in North Africa before coming back to the States to coach at the Navy's pre-flight schools. He taught and coached as an assistant at Georgia & North Carolina Navy Pre-Flight.

NORTH CAROLINA PRE-FLIGHT
U.S. NAVAL AIR STATION PROGRAM, 1944

BEFORE BAMA

1945–1958

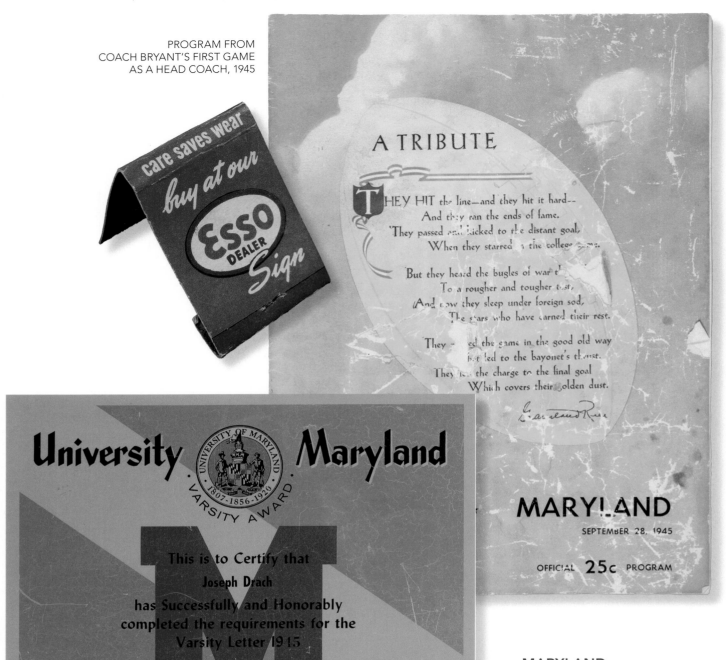

PROGRAM FROM
COACH BRYANT'S FIRST GAME
AS A HEAD COACH, 1945

care saves wear
buy at our
ESSO DEALER Sign

A TRIBUTE

THEY HIT the line—and they hit it hard--
And they ran the ends of fame.
They passed and kicked to the distant goal,
When they starred in the college game.

But they heard the bugles of war that
To a rougher and tougher test,
And now they sleep under foreign sod,
The stars who have earned their rest.

They played the game in the good old way
that led to the bayonet's thrust.
They led the charge to the final goal
Which covers their golden dust.

MARYLAND

SEPTEMBER 28, 1945

OFFICIAL 25c PROGRAM

University Maryland

UNIVERSITY OF MARYLAND
1807·1856·1920
VARSITY AWARD

This is to Certify that

Joseph Drach

has Successfully and Honorably
completed the requirements for the
Varsity Letter 1945

FOOTBALL

Paul W. Bryant
Coach

MARYLAND

After the war, Bryant
accepted the head coaching
job at the University of
Maryland. Bryant only
stayed one year, but with
this job, his head coaching
days were afoot!

TICKET
FROM COACH
BRYANT'S FIRST
GAME AS A HEAD
COACH, 1945

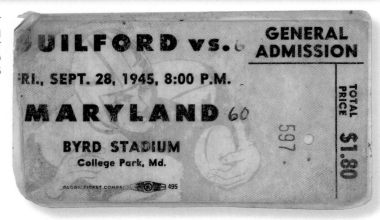

GUILFORD vs. GENERAL ADMISSION

FRI., SEPT. 28, 1945, 8:00 P.M.

MARYLAND 60

BYRD STADIUM
College Park, Md.

TOTAL PRICE $1.80

597

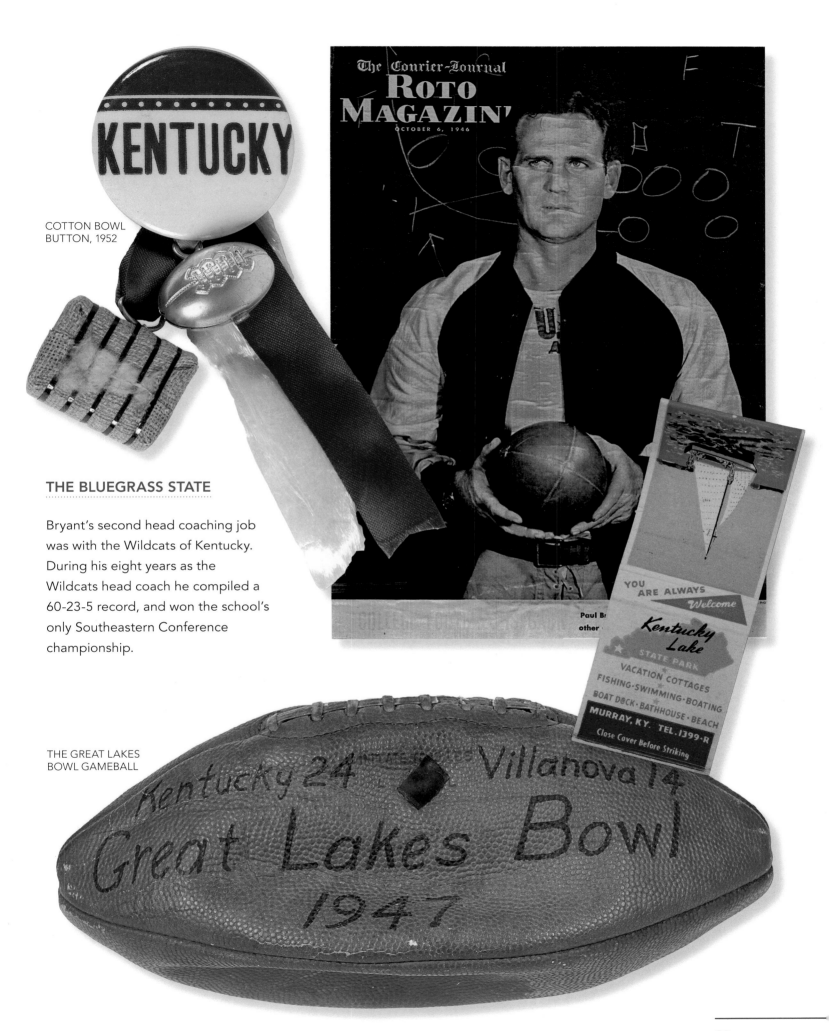

COTTON BOWL
BUTTON, 1952

The Courier-Journal
Roto
Magazine
OCTOBER 6, 1946

THE BLUEGRASS STATE

Bryant's second head coaching job was with the Wildcats of Kentucky. During his eight years as the Wildcats head coach he compiled a 60-23-5 record, and won the school's only Southeastern Conference championship.

THE GREAT LAKES
BOWL GAMEBALL

YOU ARE ALWAYS *Welcome*
Kentucky Lake
STATE PARK
VACATION COTTAGES
FISHING·SWIMMING·BOATING
BOAT DOCK·BATHHOUSE·BEACH
MURRAY, KY. TEL. 1399-R
Close Cover Before Striking

Kentucky 24 — Villanova 14
Great Lakes Bowl
1947

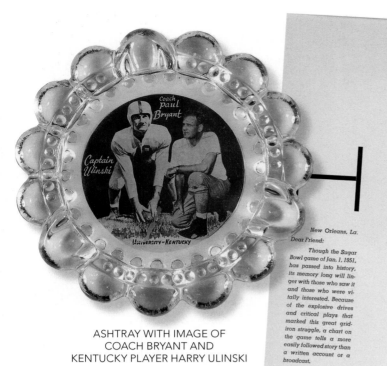

ASHTRAY WITH IMAGE OF
COACH BRYANT AND
KENTUCKY PLAYER HARRY ULINSKI

KENTUCKY VS. OKLAHOMA
PLAY BY PLAY CHART OF
THE SUGAR BOWL, 1951

New Orleans, La.

Dear Friend:

Though the Sugar Bowl game of Jan. 1, 1951, has passed into history, its memory long will linger with those who saw it and those who were vitally interested. Because of the explosive drives and critical plays that marked this great gridiron struggle, a chart on the game tells a more easily followed story than a written account or a broadcast.

I believe you, your friends and fellow workers would like to keep a copy of this chart. Space would not permit its publication in our paper of Jan. 2, so I had a cut made and had several hundred prints run off to mail to those whom I felt would appreciate a copy to preserve as a memento of what many believe was the greatest of all fine Sugar Bowl games.

All good wishes for 1951

KENTUCKY 13 · SUGAR BOWL, JAN. 1, 1951 · OKLAHOMA 7

THE TIMES-PICAYUNE CHART
SUGAR BOWL, JAN. 1, 1951

FIRST QUARTER

SECOND QUARTER

THIRD QUARTER

FOURTH QUARTER

KEY
++++ KICKOFF
•—•—• RUN
|||||| PASS
|||||| PUNT
~~~~ RETURN
—— PENALTY

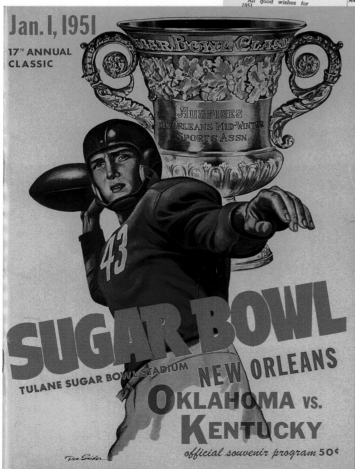

Jan. 1, 1951
17ᵀᴴ ANNUAL CLASSIC

SUGAR BOWL
TULANE SUGAR BOWL STADIUM
NEW ORLEANS
OKLAHOMA VS. KENTUCKY
official souvenir program 50¢

THE SUGAR BOWL
KENTUCKY
NEW ORLEANS, LA.

SUGAR BOWL
BUTTON, 1951

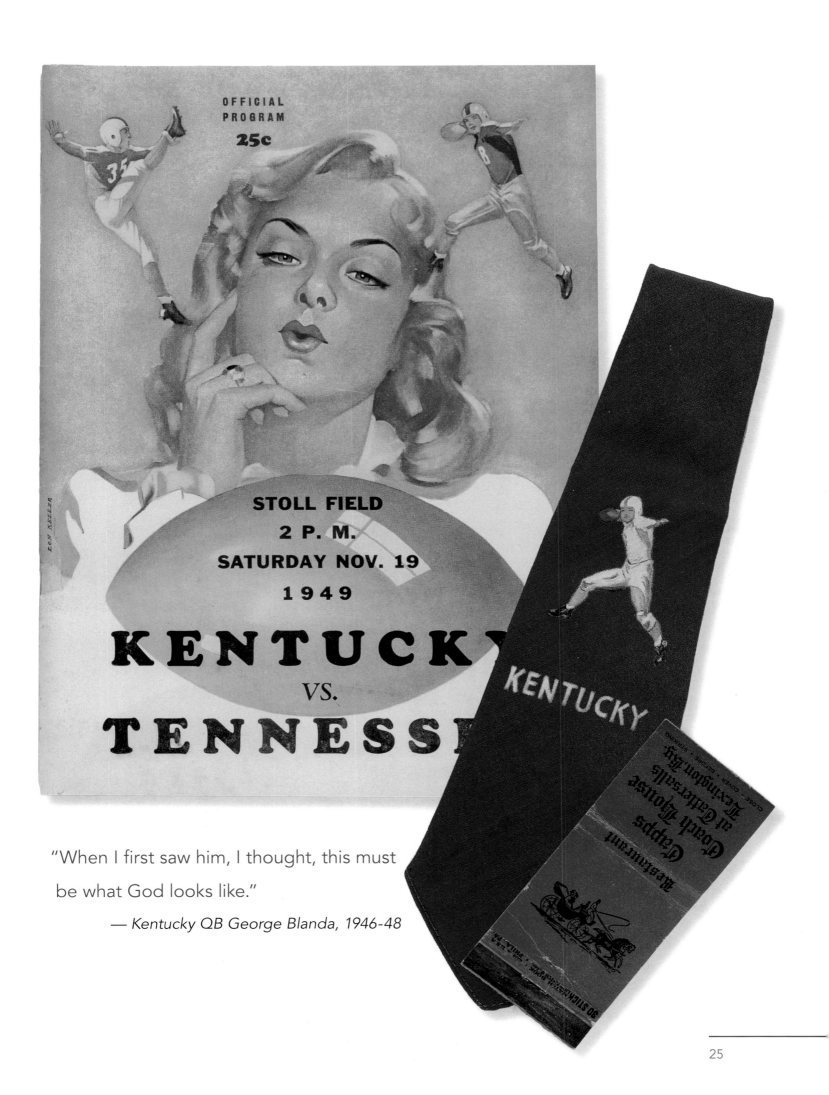

OFFICIAL PROGRAM
25c

STOLL FIELD
2 P. M.
SATURDAY NOV. 19
1949

KENTUCKY
VS.
TENNESSE

"When I first saw him, I thought, this must
be what God looks like."

— *Kentucky QB George Blanda, 1946-48*

25

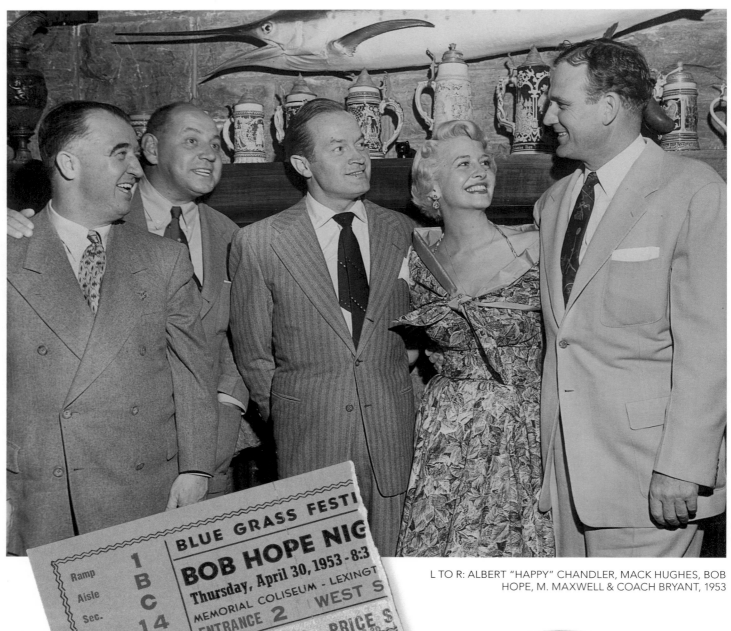

L TO R: ALBERT "HAPPY" CHANDLER, MACK HUGHES, BOB HOPE, M. MAXWELL & COACH BRYANT, 1953

L TO R: TWO UNIDENTIFIED MEN, PAUL BRYANT, ADOLPH RUPP, 1946

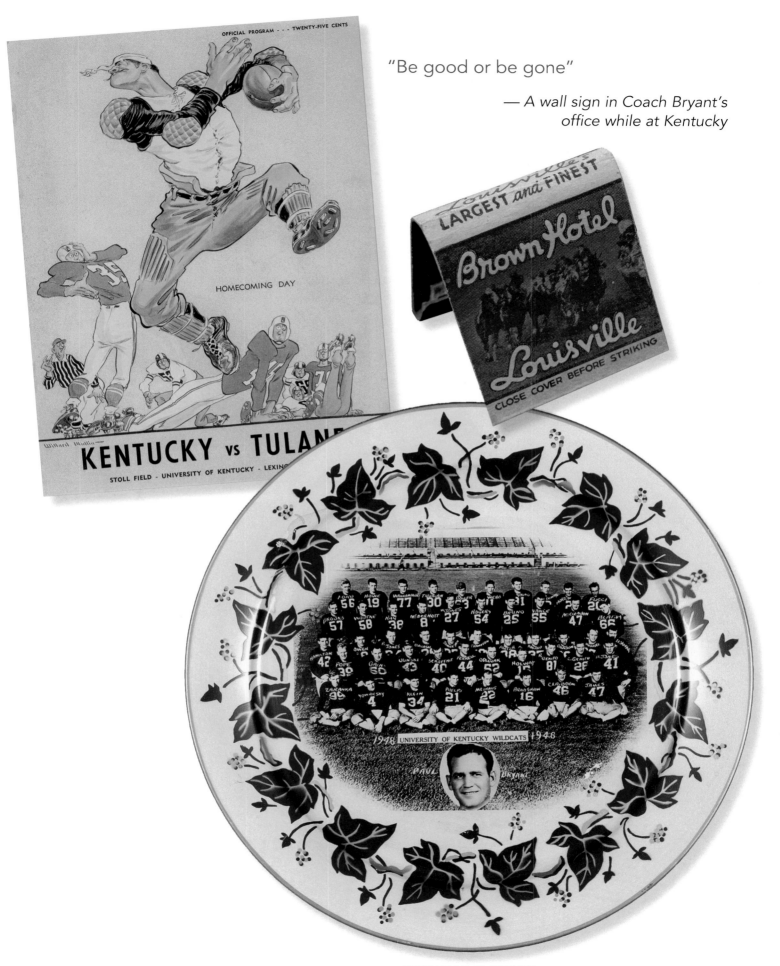

"Be good or be gone"

— A wall sign in Coach Bryant's
office while at Kentucky

CEREMONIAL PLATE WITH
KENTUCKY TEAM PHOTOGRAPH, 1948

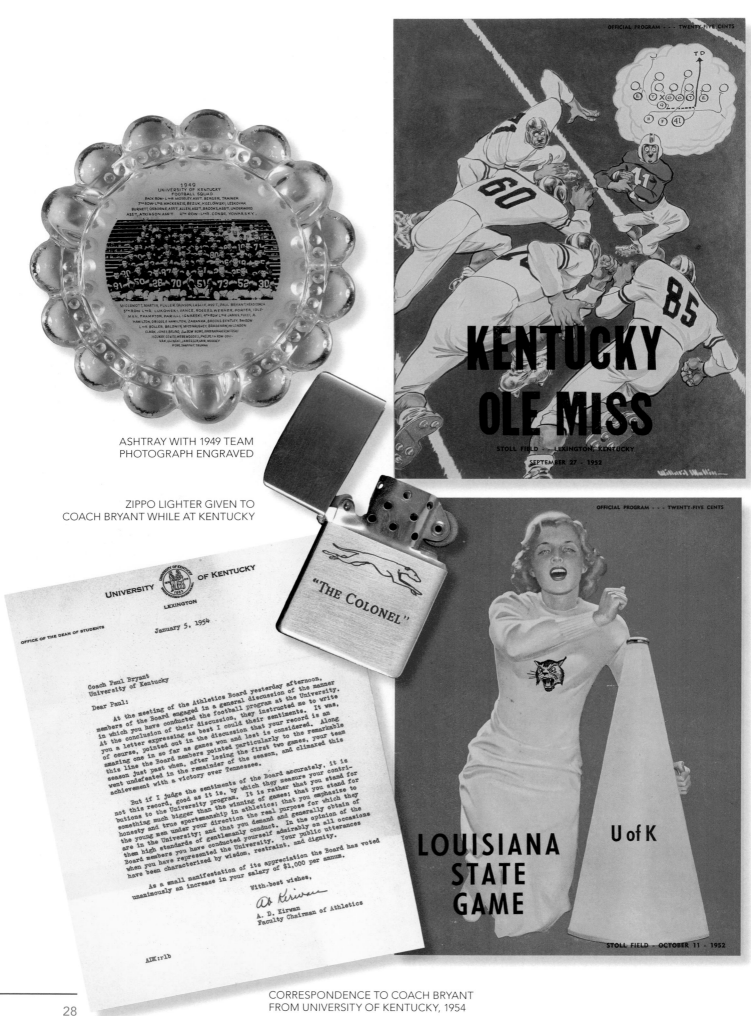

ASHTRAY WITH 1949 TEAM
PHOTOGRAPH ENGRAVED

ZIPPO LIGHTER GIVEN TO
COACH BRYANT WHILE AT KENTUCKY

CORRESPONDENCE TO COACH BRYANT
FROM UNIVERSITY OF KENTUCKY, 1954

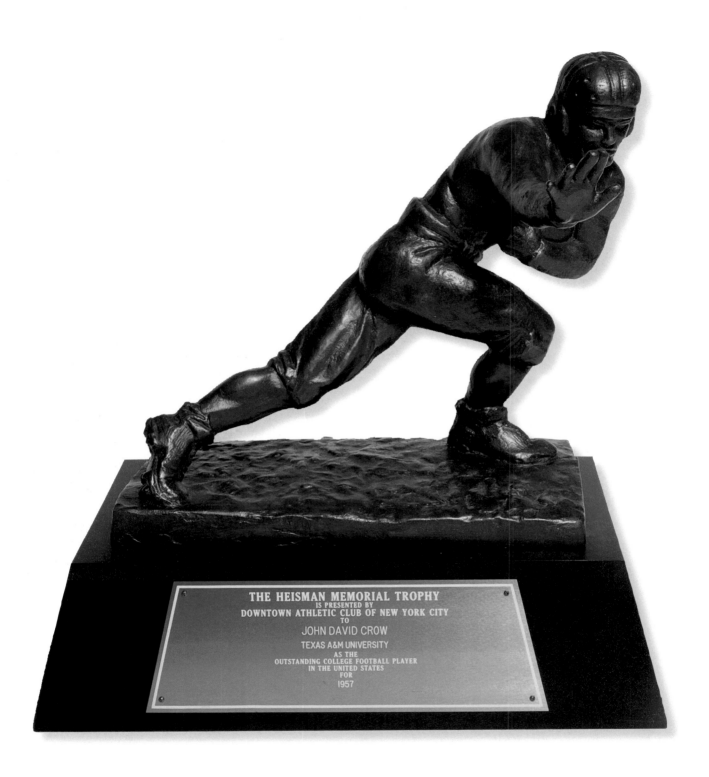

THE HEISMAN MEMORIAL TROPHY
IS PRESENTED BY
DOWNTOWN ATHLETIC CLUB OF NEW YORK CITY
TO
JOHN DAVID CROW
TEXAS A&M UNIVERSITY
AS THE
OUTSTANDING COLLEGE FOOTBALL PLAYER
IN THE UNITED STATES
FOR
1957

"If a man is a quitter, I'd rather find out in
practice than in a game. I ask for all a player has,
so I'll know later what I can expect."

— *Coach Bryant*

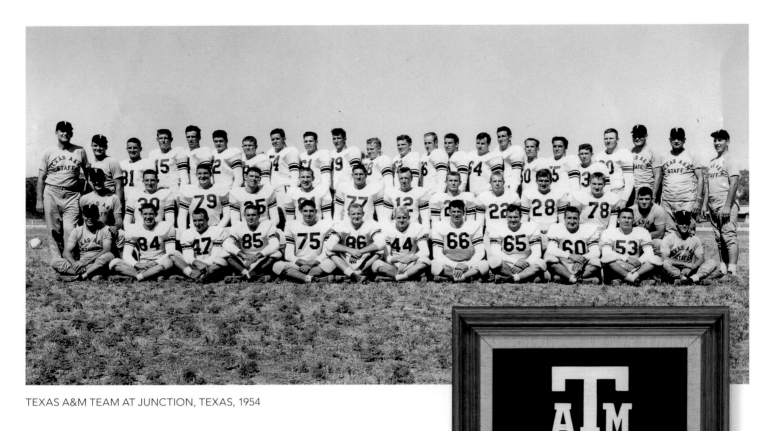

TEXAS A&M TEAM AT JUNCTION, TEXAS, 1954

BILLY PICKARD'S TEXAS A&M JACKET, 1955

T
A M
FOOTBALL

CLASSES OF '54, '55, '56 & '57
REUNION 1975
IN APPRECIATION TO
COACH PAUL "BEAR" BRYANT

## JUNCTION BOYS

Most events that become legends grow bigger with the passage of time, but the story of the 1954 Texas A&M football team and their ten day ordeal in Junction, Texas reached legendary status as soon as the returning players stepped off the bus.

To get away from all the distractions on campus, first year head coach Paul Bryant loaded his 96 players onto two buses and took them to an out of the way, off-campus site, in Junction, Texas. Bryant and his staff drove them mercilessly for ten days. Starting at 5:00 a.m. and going to dark. Players threw up, passed out, and left in droves. By the end, only one bus was needed to take the 27 players back to campus.

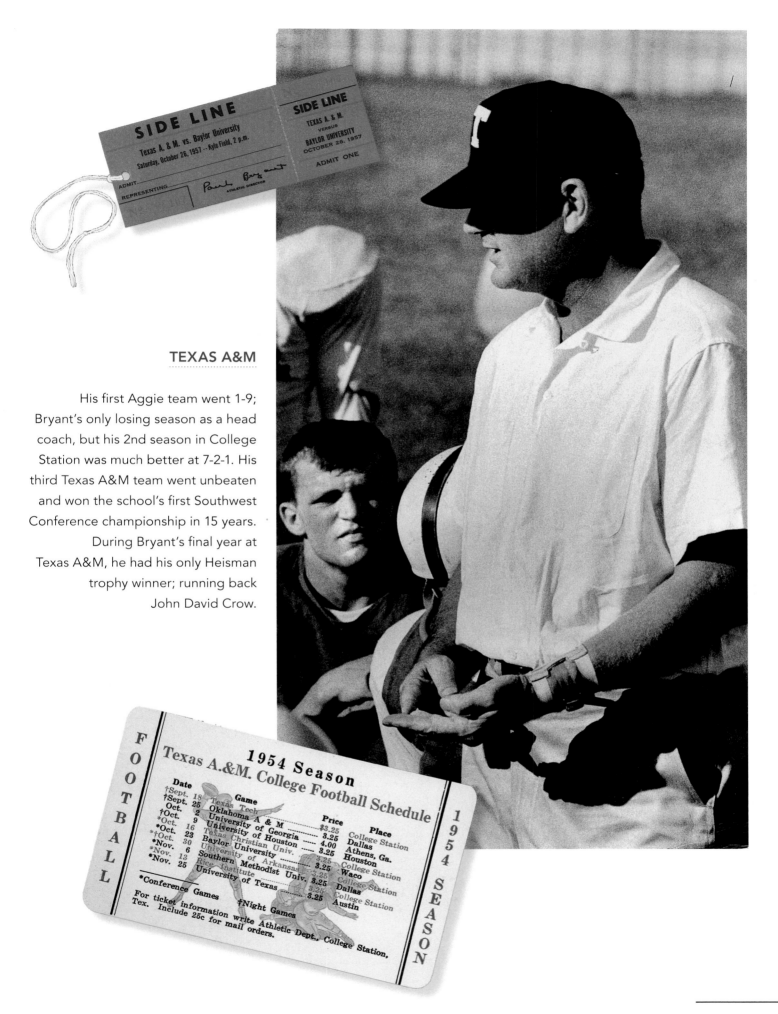

## TEXAS A&M

His first Aggie team went 1-9;
Bryant's only losing season as a head
coach, but his 2nd season in College
Station was much better at 7-2-1. His
third Texas A&M team went unbeaten
and won the school's first Southwest
Conference championship in 15 years.
During Bryant's final year at
Texas A&M, he had his only Heisman
trophy winner; running back
John David Crow.

SIDE LINE
Texas A. & M. vs. Baylor University
Saturday, October 26, 1957 -- Kyle Field, 2 p.m.

ADMIT
REPRESENTING _____ *Paul Bryant* ATHLETIC DIRECTOR

SIDE LINE
TEXAS A. & M.
VERSUS
BAYLOR UNIVERSITY
OCTOBER 26, 1957

ADMIT ONE

F
O
O
T
B
A
L
L

**1954 Season**
**Texas A.&M. College Football Schedule**

| Date | Game | Price | Place |
|------|------|-------|-------|
| †Sept. 18 | Texas Tech | | College Station |
| †Sept. 25 | Oklahoma A & M | $3.25 | Dallas |
| Oct. 2 | University of Georgia | 3.25 | Athens, Ga. |
| †Oct. 9 | University of Houston | 4.00 | Houston |
| *Oct. 16 | Texas Christian Univ. | 3.25 | College Station |
| *†Oct. 23 | Baylor University | 3.25 | Waco |
| *Nov. 30 | University of Arkansas | 3.25 | College Station |
| *Nov. 6 | Southern Methodist Univ. | 3.25 | Dallas |
| *Nov. 13 | Rice Institute | 3.25 | College Station |
| Nov. 25 | University of Texas | 3.25 | Austin |

*Conference Games          †Night Games

For ticket information write Athletic Dept., College Station,
Tex. Include 25c for mail orders.

1
9
5
4

S
E
A
S
O
N

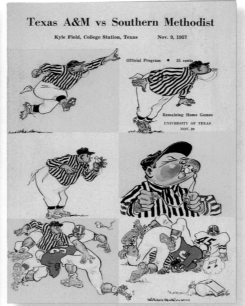

"It is unbelievable the oneness that he developed in his coaches and players."

— *Pat James*

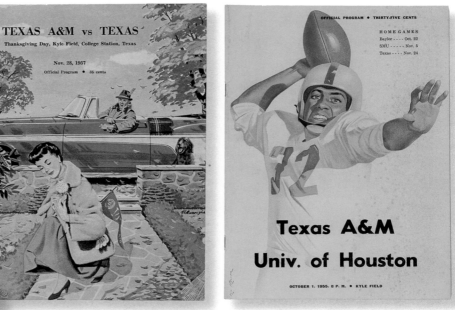

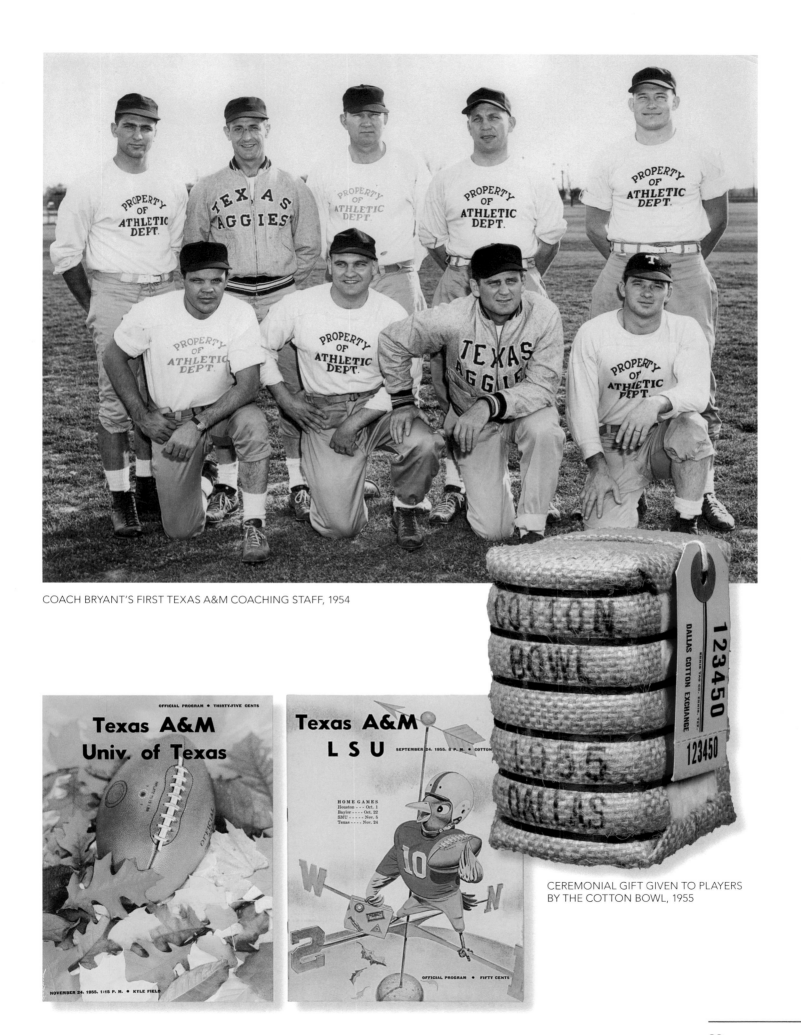

COACH BRYANT'S FIRST TEXAS A&M COACHING STAFF, 1954

CEREMONIAL GIFT GIVEN TO PLAYERS
BY THE COTTON BOWL, 1955

# MAMA CALLED

## 1958–1967

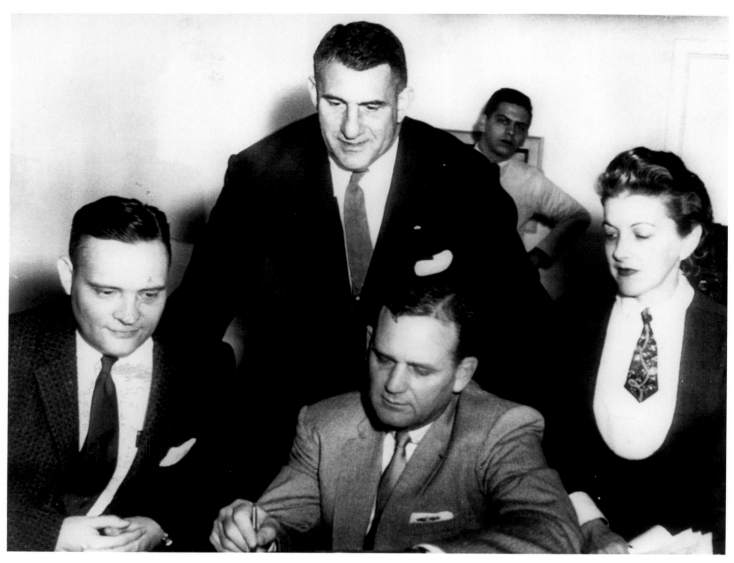

FOUNTAIN PEN USED TO SIGN COACH BRYANT'S
UNIVERSITY OF ALABAMA CONTRACT, 1957

COACH BRYANT SIGNING UNIVERSITY
OF ALABAMA CONTRACT, PICTURED
WITH COACH BRYANT, L TO R BOARD OF
TRUSTEE MEMBER ERNEST WILLIAMS,
FRED SINGTON (STANDING) MARY
HARMON, UNKNOWN IN BACK.

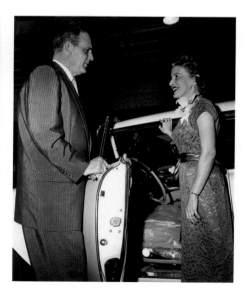

COACH AND MRS. BRYANT, 1957

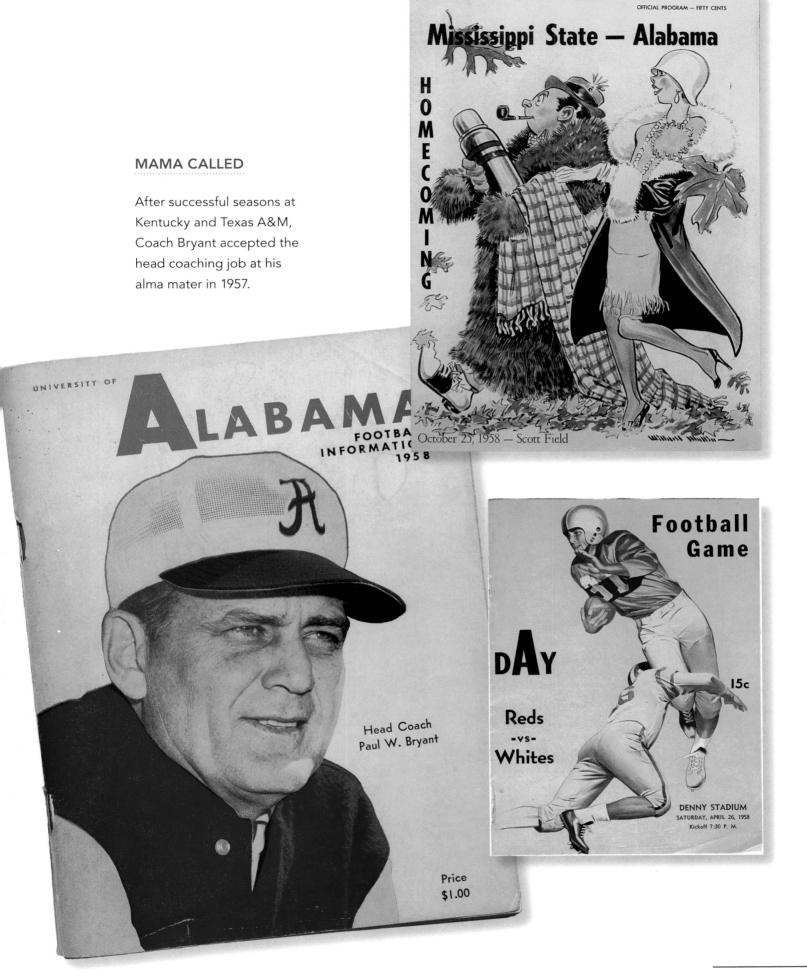

## MAMA CALLED

After successful seasons at Kentucky and Texas A&M, Coach Bryant accepted the head coaching job at his alma mater in 1957.

OFFICIAL PROGRAM — FIFTY CENTS

**Mississippi State — Alabama**

**HOMECOMING**

October 25, 1958 — Scott Field

UNIVERSITY OF

**ALABAMA**

FOOTBA
INFORMATIO
1958

Head Coach
Paul W. Bryant

Price
$1.00

**Football Game**

**dAy**

Reds
-vs-
Whites

15c

DENNY STADIUM
SATURDAY, APRIL 26, 1958
Kickoff 7:30 P. M.

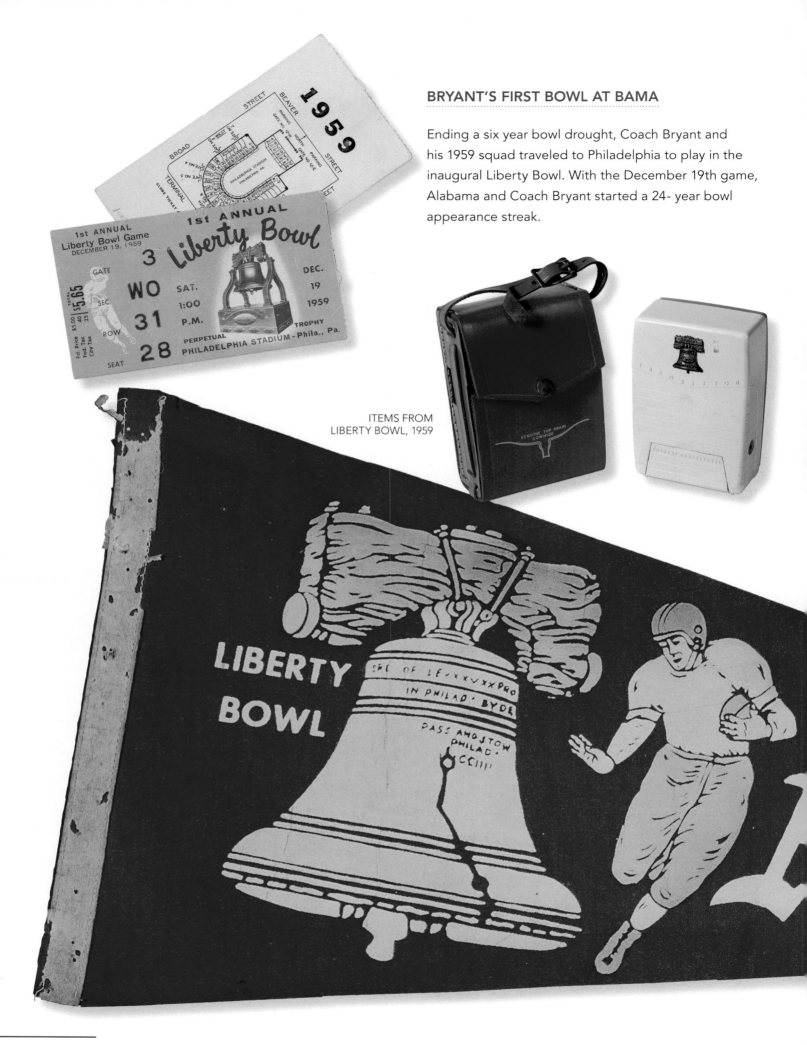

## BRYANT'S FIRST BOWL AT BAMA

Ending a six year bowl drought, Coach Bryant and his 1959 squad traveled to Philadelphia to play in the inaugural Liberty Bowl. With the December 19th game, Alabama and Coach Bryant started a 24- year bowl appearance streak.

ITEMS FROM
LIBERTY BOWL, 1959

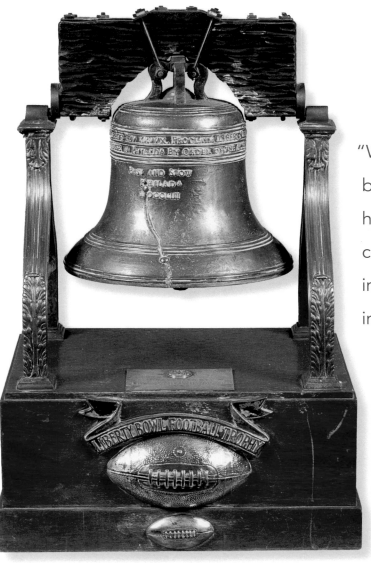

LIBERTY BOWL TROPHY, 1959

"We weren't a real strong team, but that team would hit you. We had the makings of something good a couple of years later and it was important for them to get started in the bowl business."

— *Coach Bryant talking about the 1959 team*

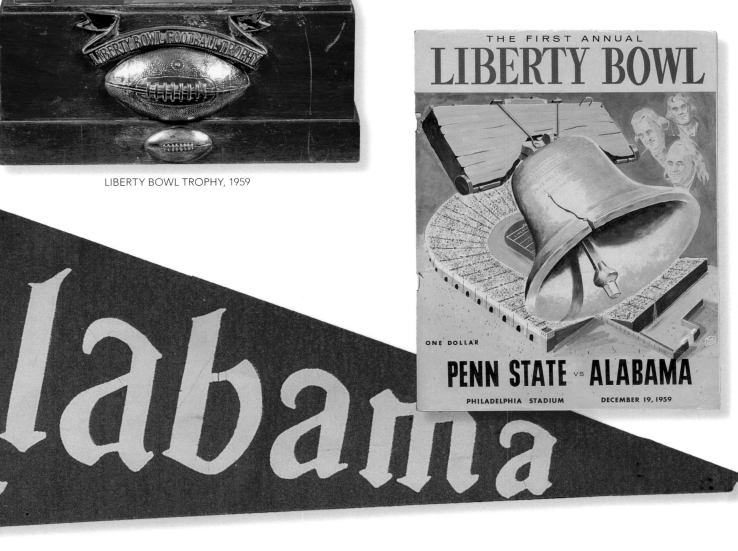

## CROSS STATE RIVALS

After beating Auburn 10-0 and finishing the 1959 regular season 7-1-2 Alabama returned to the nation's elite football programs, with a top 10 AP ranking.

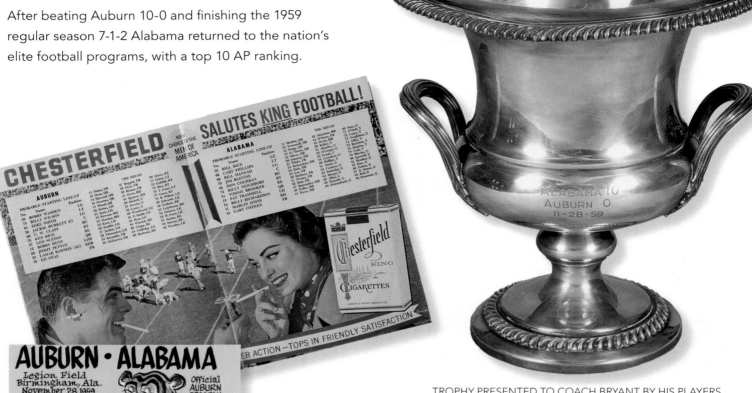

TROPHY PRESENTED TO COACH BRYANT BY HIS PLAYERS AFTER HIS FIRST VICTORY OVER AUBURN, 1959

"We were in the first meeting with Coach Bryant and he told us in four years if we believed in his plan and dedicated ourselves to being the best we could be we would be national champions. He was right."

— *Billy Neighbors*

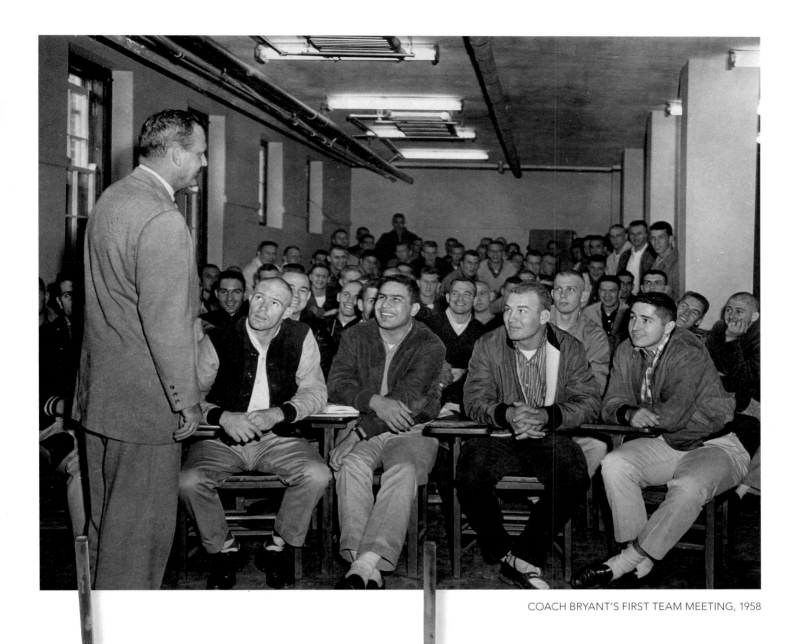

COACH BRYANT'S FIRST TEAM MEETING, 1958

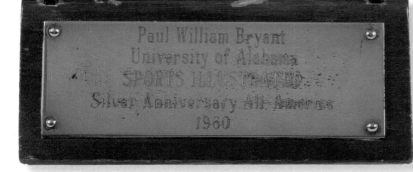

SPORTS ILLUSTRATED SILVER
ANNIVERSARY AWARD, 1960

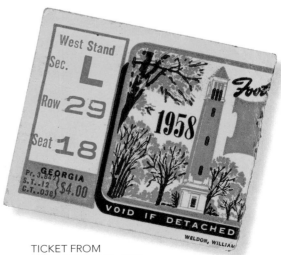

TICKET FROM
GEORGIA GAME, 1958

"Regardless of who was coaching them, they still would have been a great team, I said early in the season that they were the nicest, even sissiest, bunch I ever had. I think they read it, because later on they got unfriendly."

— Bryant on 1961 team

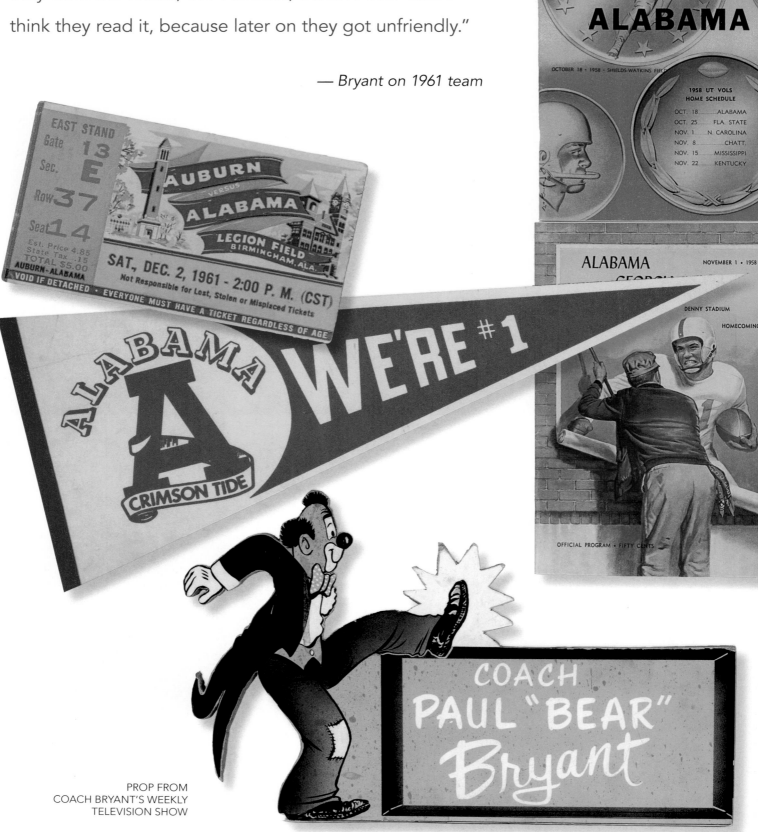

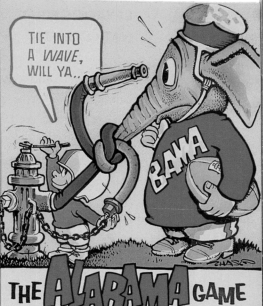

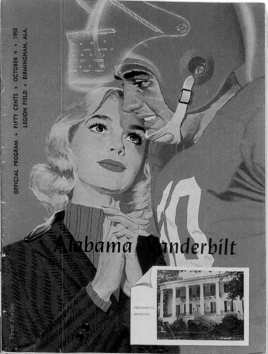

PROGRAMS FROM COACH BRYANT'S FIRST YEAR AT ALABAMA, 1958

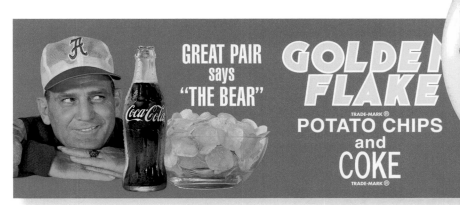

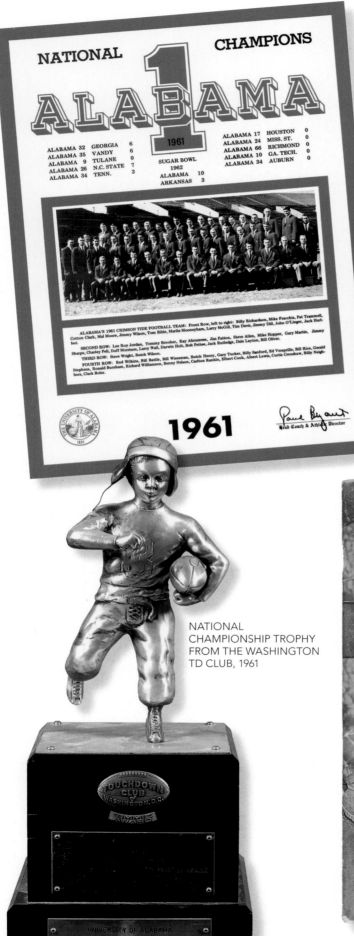

NATIONAL **1** CHAMPIONS
ALABAMA
1961

| ALABAMA 32 | GEORGIA | 6 |
| ALABAMA 35 | VANDY | 6 |
| ALABAMA 9 | TULANE | 0 |
| ALABAMA 26 | N.C. STATE | 7 |
| ALABAMA 34 | TENN. | 3 |

SUGAR BOWL
1962
ALABAMA 10
ARKANSAS 3

| ALABAMA 17 | HOUSTON | 0 |
| ALABAMA 24 | MISS. ST. | 0 |
| ALABAMA 66 | RICHMOND | 0 |
| ALABAMA 10 | GA. TECH. | 0 |
| ALABAMA 34 | AUBURN | 0 |

ALABAMA'S 1961 CRIMSON TIDE FOOTBALL TEAM: Front Row, left to right: Billy Richardson, Mike Fracchia, Pat Trammell, Cotton Clark, Mal Moore, Jimmy Wilson, Tom Bible, Marlin Mooneyham, Larry McGill, Tim Davis, Jimmy Dill, John O'Linger, Jack Hurlbut. SECOND ROW: Lee Roy Jordan, Tommy Brooker, Ray Abruzzese, Jim Patton, Steve Allen, Mike Hopper, Gary Martin, Jimmy Sharpe, Charley Pell, Duff Morrison, Larry Wall, Darwin Holt, Bob Pettee, Jack Rutledge, Dale Layton, Bill Oliver. THIRD ROW: Steve Wright, Butch Wilson. FOURTH ROW: Red Wilkins, Bill Battle, Bill Wieseman, Butch Henry, Gary Tucker, Billy Sanford, Ed Versprille, Bill Rice, Gerald Stephens, Ronald Burnham, Richard Williamson, Benny Nelson, Carlton Rankin, Elbert Cook, Albert Lewis, Curtis Crenshaw, Billy Neighbors, Clark Boler.

1961

*Paul Bryant*
Head Coach & Athletic Director

NATIONAL
CHAMPIONSHIP TROPHY
FROM THE WASHINGTON
TD CLUB, 1961

## BRYANT'S FIRST NATIONAL CHAMPIONSHIP

During his first three seasons at Alabama the Crimson Tide made steady improvement; Bryant's 1961 team took the University to new heights. Led by quarterback Pat Trammell, and All-America Lee Roy Jordan, the Tide would outscore its foes 297-25, and shut out 6 of its 11 opponents on the way to a perfect 11-0 record.

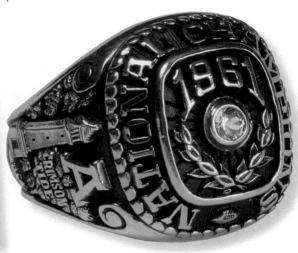

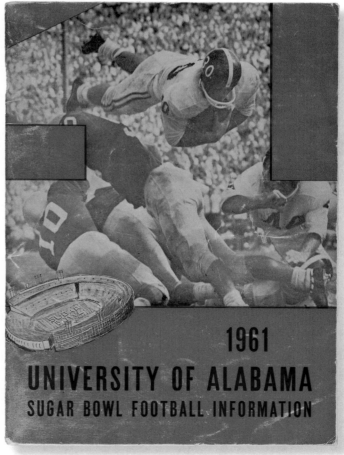

1961
UNIVERSITY OF ALABAMA
SUGAR BOWL FOOTBALL INFORMATION

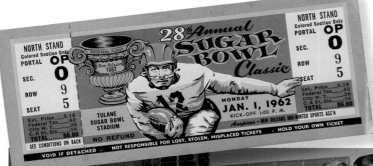

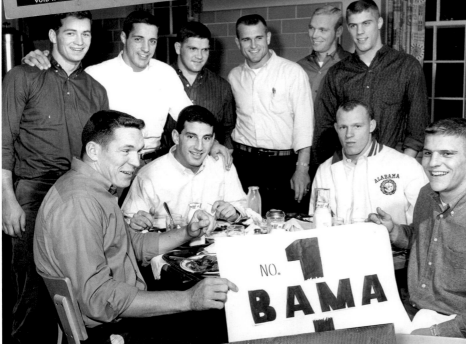

"They play like it is a sin

to give up a point."

— *Coach Bryant
on the 1961 team*

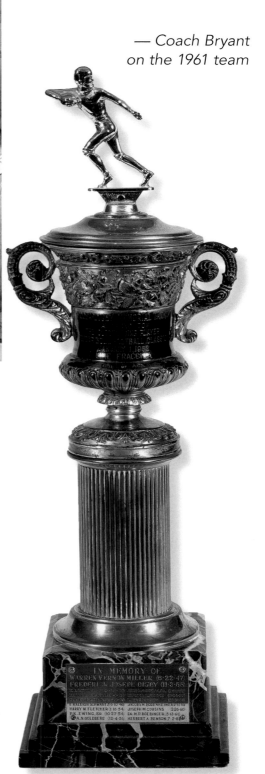

SUGAR BOWL TROPHY, 1962

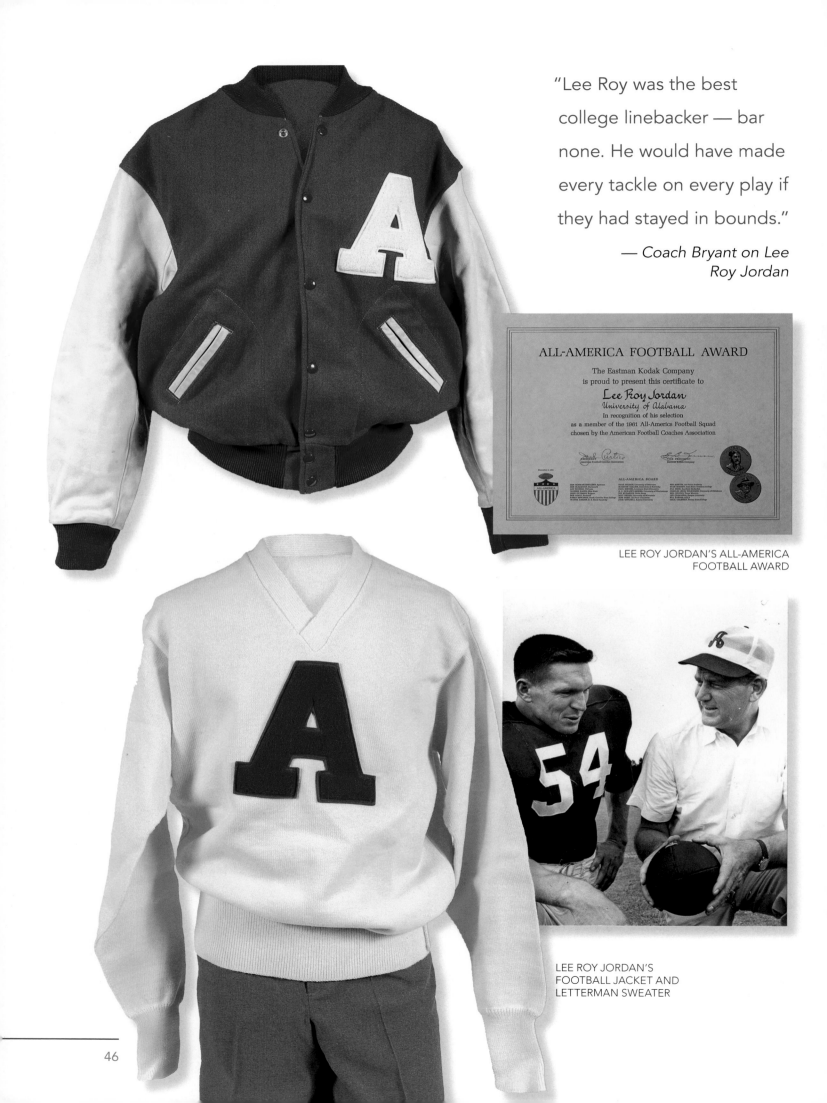

"Lee Roy was the best college linebacker — bar none. He would have made every tackle on every play if they had stayed in bounds."

— *Coach Bryant on Lee Roy Jordan*

LEE ROY JORDAN'S ALL-AMERICA FOOTBALL AWARD

LEE ROY JORDAN'S FOOTBALL JACKET AND LETTERMAN SWEATER

46

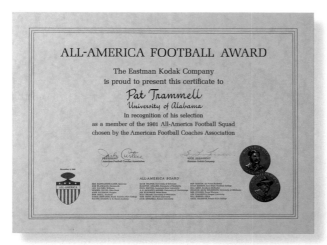

PAT TRAMMELL, 1961

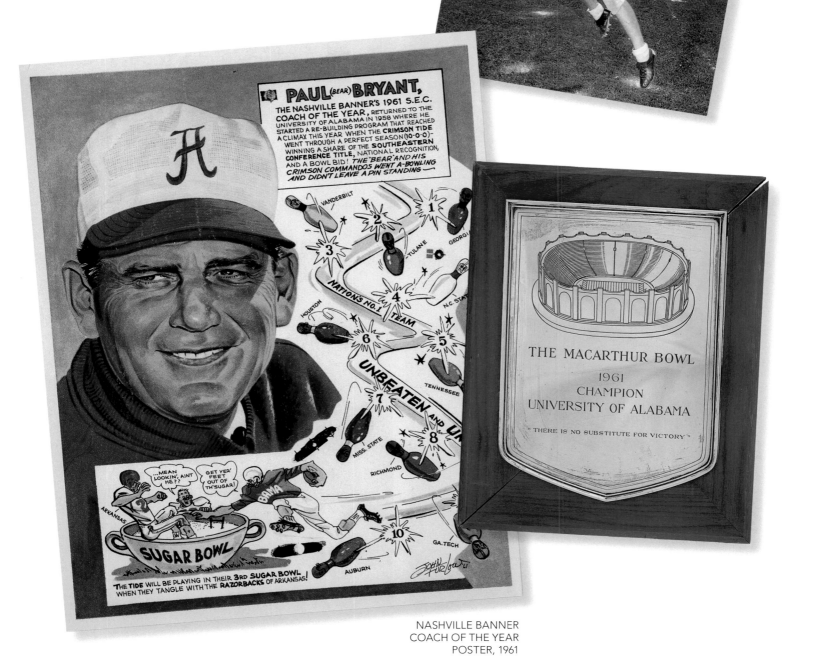

NASHVILLE BANNER
COACH OF THE YEAR
POSTER, 1961

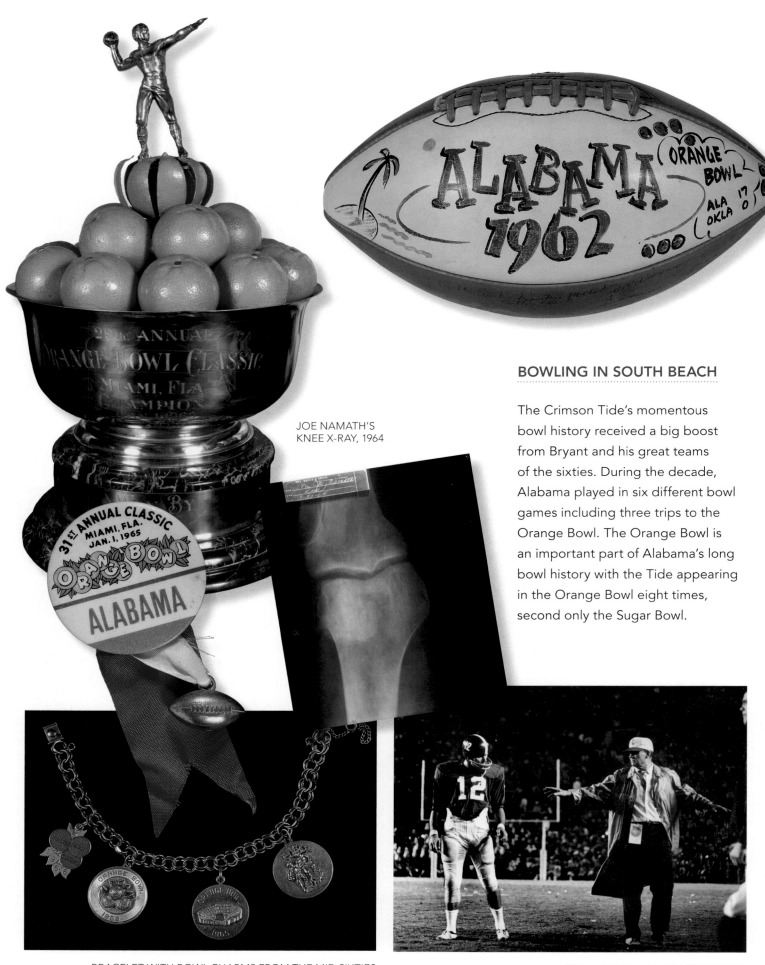

JOE NAMATH'S
KNEE X-RAY, 1964

## BOWLING IN SOUTH BEACH

The Crimson Tide's momentous bowl history received a big boost from Bryant and his great teams of the sixties. During the decade, Alabama played in six different bowl games including three trips to the Orange Bowl. The Orange Bowl is an important part of Alabama's long bowl history with the Tide appearing in the Orange Bowl eight times, second only the Sugar Bowl.

BRACELET WITH BOWL CHARMS FROM THE MID SIXTIES

JOE NAMATH AND COACH BRYANT
DURING THE ORANGE BOWL, 1965

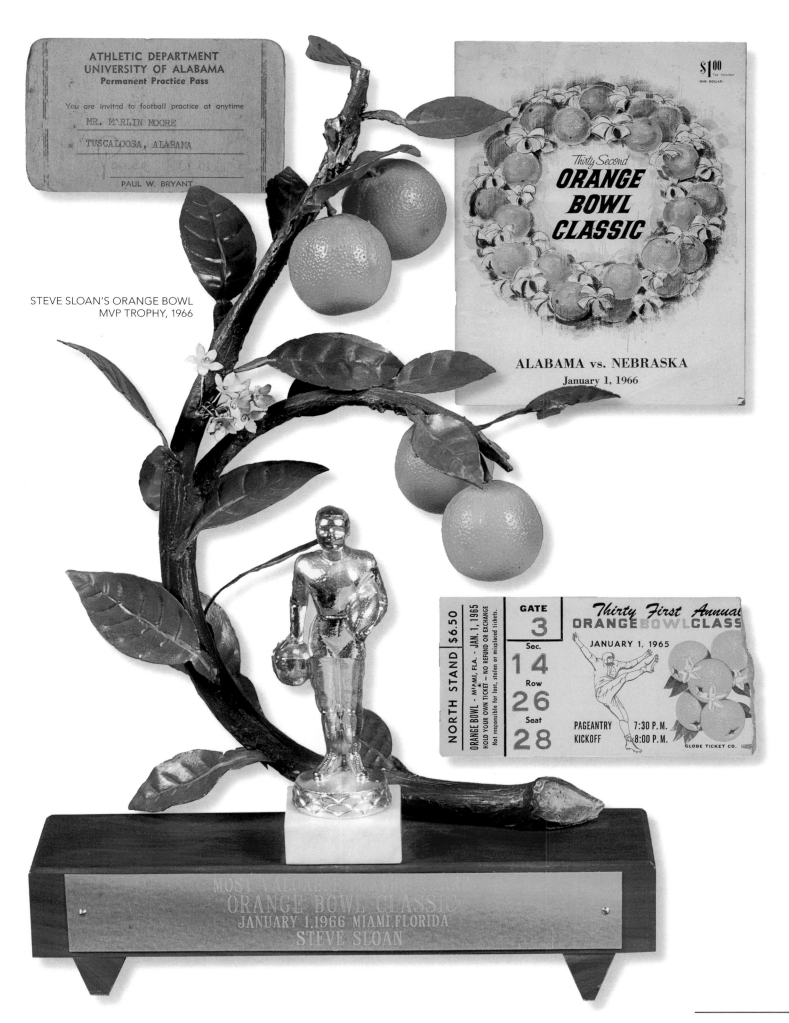

ATHLETIC DEPARTMENT
UNIVERSITY OF ALABAMA
Permanent Practice Pass

You are invited to football practice at anytime

MR. MARLIN MOORE

TUSCALOOSA, ALABAMA

PAUL W. BRYANT

$1.00
Tax Included
(ONE DOLLAR)

*Thirty Second*
ORANGE
BOWL
CLASSIC

ALABAMA vs. NEBRASKA
January 1, 1966

STEVE SLOAN'S ORANGE BOWL
MVP TROPHY, 1966

NORTH STAND $6.50

ORANGE BOWL – MIAMI, FLA. – JAN. 1, 1965
HOLD YOUR OWN TICKET – NO REFUND OR EXCHANGE
Not responsible for lost, stolen or misplaced tickets.

GATE
3
Sec.
14
Row
26
Seat
28

*Thirty First Annual*
ORANGE BOWL CLASSIC
JANUARY 1, 1965

PAGEANTRY    7:30 P.M.
KICKOFF      8:00 P.M.

GLOBE TICKET CO.

MOST VALUABLE PLAYER AWARD
ORANGE BOWL CLASSIC
JANUARY 1, 1966 MIAMI, FLORIDA
STEVE SLOAN

## BUILDING FOR THE FUTURE:

As The University of Alabama's athletic director, Bryant understood the importance of innovative facilities. For this reason he oversaw the upgrade of Denny Stadium. He built a deluxe athletic dormitory, an Olympic size natatorium, and a multi-purpose state of the art coliseum, all within his first ten years. Coach Bryant may have been an old school coach, but he always had his eyes on the future.

DENNY STADIUM, 1966

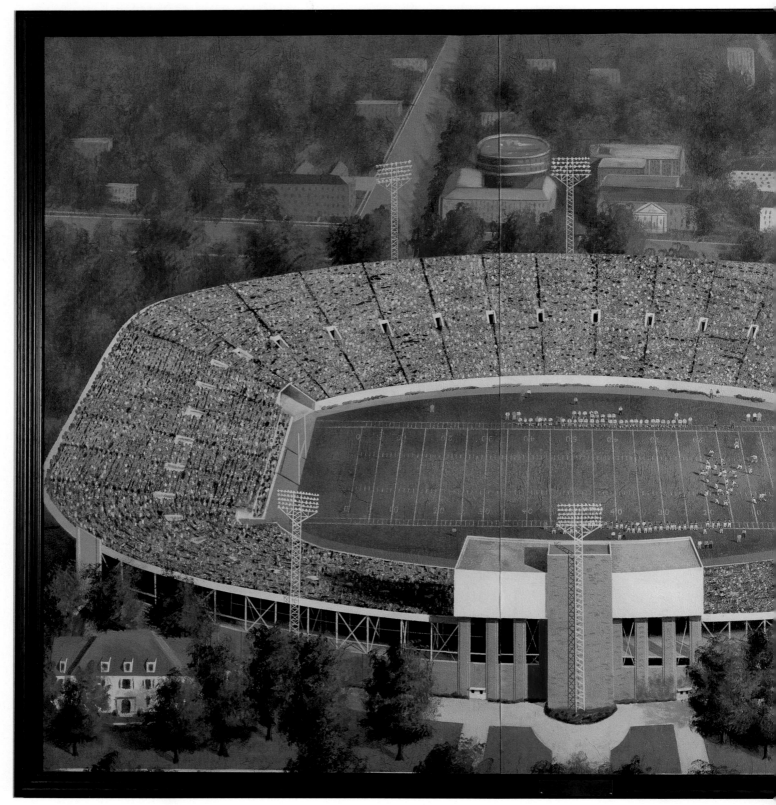

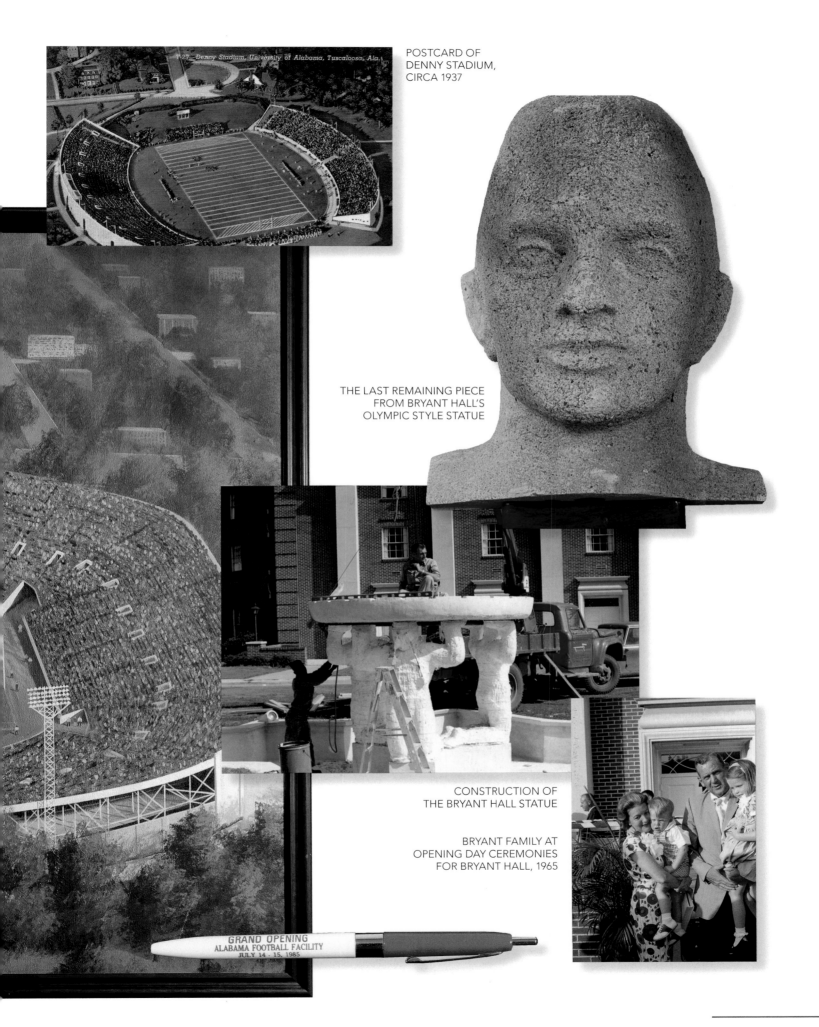

POSTCARD OF
DENNY STADIUM,
CIRCA 1937

THE LAST REMAINING PIECE
FROM BRYANT HALL'S
OLYMPIC STYLE STATUE

CONSTRUCTION OF
THE BRYANT HALL STATUE

BRYANT FAMILY AT
OPENING DAY CEREMONIES
FOR BRYANT HALL, 1965

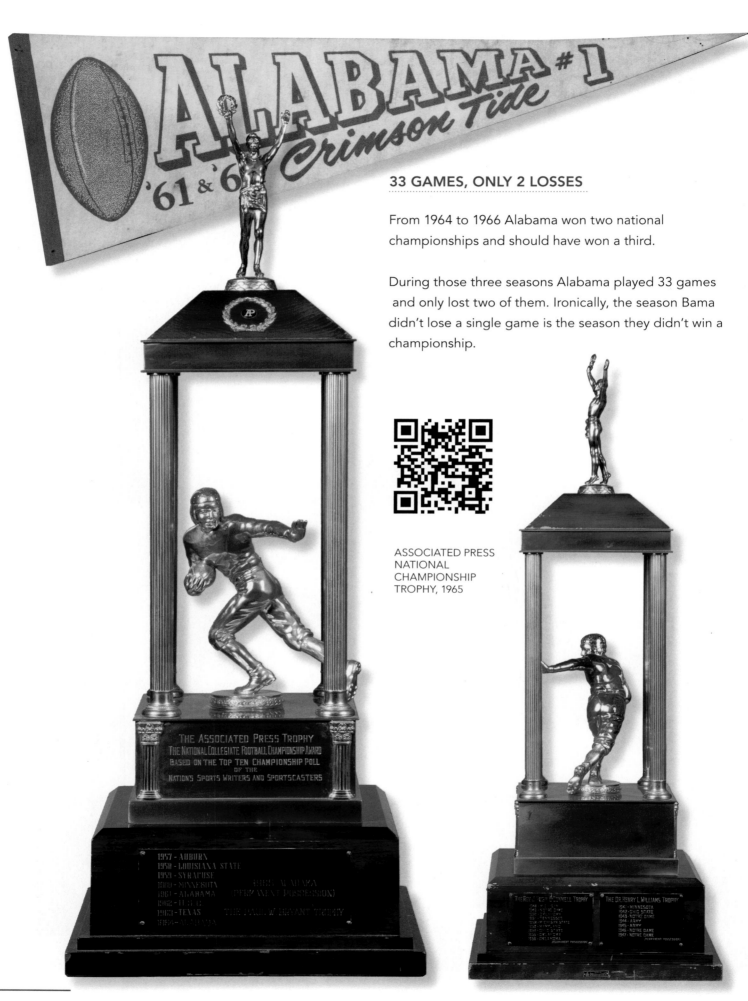

## 33 GAMES, ONLY 2 LOSSES

From 1964 to 1966 Alabama won two national championships and should have won a third.

During those three seasons Alabama played 33 games and only lost two of them. Ironically, the season Bama didn't lose a single game is the season they didn't win a championship.

ASSOCIATED PRESS NATIONAL CHAMPIONSHIP TROPHY, 1965

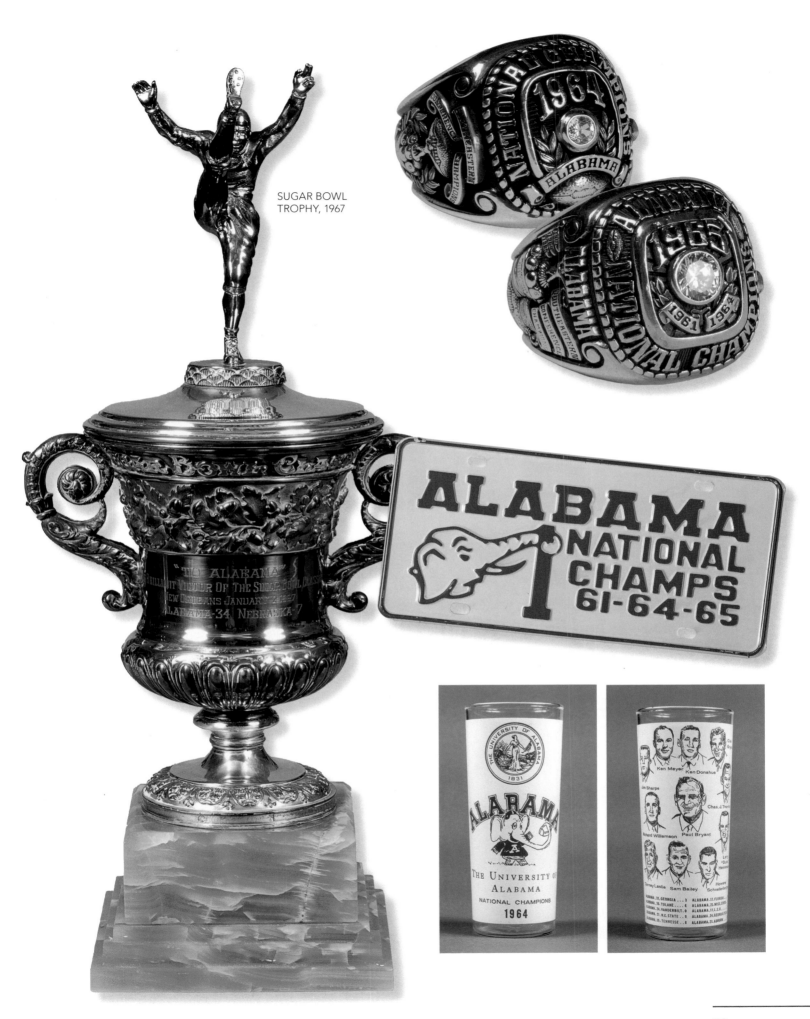

SUGAR BOWL
TROPHY, 1967

"TO ALABAMA"
BRILLIANT VICTOR OF THE SUGAR BOWL CLASSIC
NEW ORLEANS JANUARY 2, 1967
ALABAMA-34 NEBRASKA-7

1964

1965
1961 1964

ALABAMA
NATIONAL
CHAMPS
61-64-65

THE UNIVERSITY OF ALABAMA
1831

ALABAMA

THE UNIVERSITY OF
ALABAMA
NATIONAL CHAMPIONS
1964

Ken Meyer   Ken Donahue

Jim Sharpe                    Chas. J. Thom

Richard Williamson    Paul Bryant

Carney Laslie   Sam Bailey   Howard Schnellenb

## THE AMAZING 60'S

Coach Bryant's Crimson Tide teams of the 60s compiled a remarkable record of 90-16-4. Not only did Alabama win more games than anyone else during the period, they also held the nation's best winning percentage at 84%.

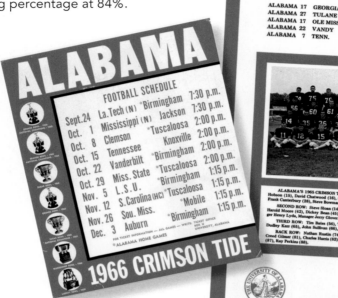

NATIONAL CHAMPIONSHIP POSTER
AND 1966 SCHEDULE POSTER

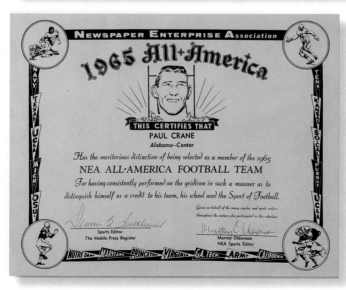

PAUL CRANE'S NEA ALL-AMERICA AWARD

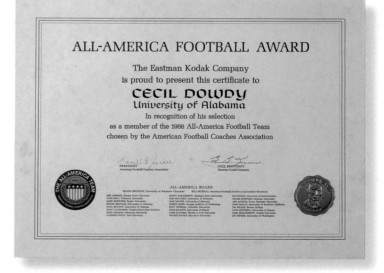

CECIL DOWDY'S EASTMAN KODAK ALL- AMERICA AWARD

## Alabama's 1966 SEC co-ch...

This Crimson Tide went unbeaten and untied to share title w...

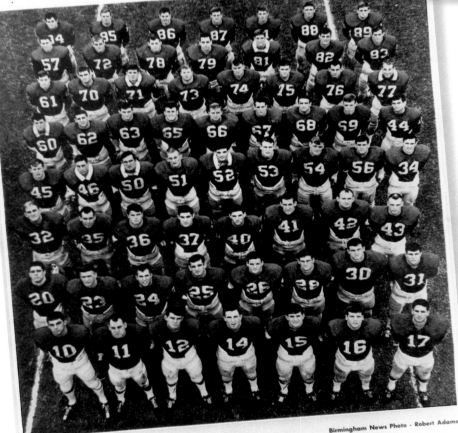

Birmingham News Photo - Robert Adams

## In famed battle dress of red and wh...

Wayne Trimble (10), Dudley Kerr (11), Kenny Stabler (12), Joe Kelley (14), Melvin Brunson (15), Mike Sassei (16), Steve Davis...
Donnie Johnston (20), Donnie Sutton (23), John Mosley (24), Dennis Homan (25), Dicky Bean (26), Frank Canterbury (28), Jun...
Les Kelley (32), Gene Raburn (35), Wayne Owen (36), Bobby Johns (37), Kenny Martin (40), John Reitz (41), Hal Moore (42), E...
Ed Morgan (45), David Bedwell (46), Stan Moss (50), Ed Wright (51), Terry Killgore (52), Jimmy Carroll (53), Mike Hall (54), ...
Tom Somerville (60), John Calvert (62), Norris Hamer (63), Mike Reilly (65), John Sullivan (66), Billy Johnson (67), B...
Thompson (44).
Byrd Williams (61), Cecil Dowdy (70), John Sides (71), Jimmy Fuller (73), Nathan Rustin (74), Taze Fulford (75), Chris V...
Robert Higginbotham (57), Randy Barron (72), Louis Thompson (78), Richard Cole (79), Mike Ford (81), Charles Harris (8...
Eddie Bo Rogers (84), Don Shankles (85), Billy Scroggins (86), Wayne Stevens (87), Richard Brewer (21), Ray Perkins (...

"It's the greatest
football team I've ever been
associated with. It's the
greatest football team
I ever saw."

— *Coach Bryant on his
1966 team*

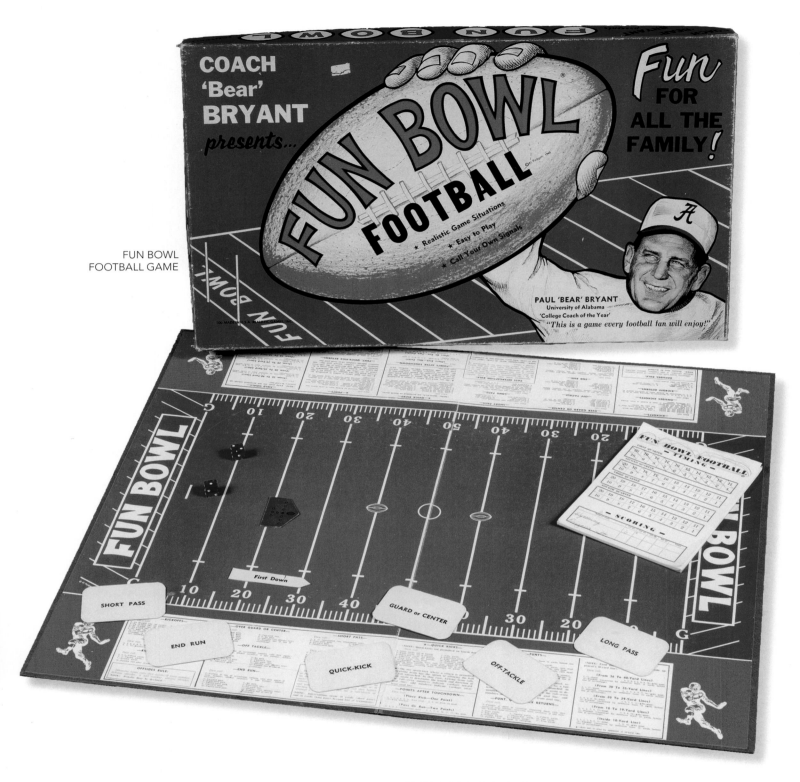

FUN BOWL
FOOTBALL GAME

## FUN AND GAMES

Coach Bryant was not the first athletic persona to endorse products, but he certainly embraced the idea. The Fun Bowl game was produced by Realistic Games, Inc. in 1962. The board game is a roll and move game for two players.

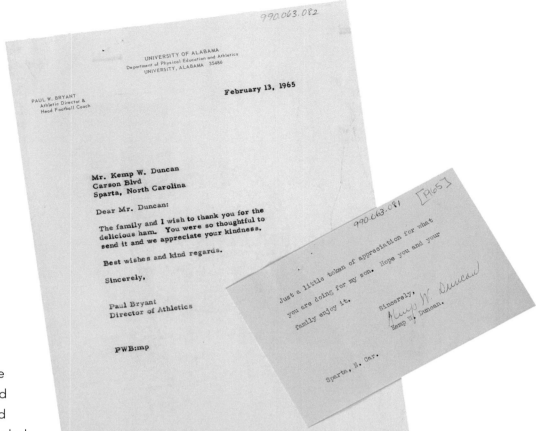

990.063.082

UNIVERSITY OF ALABAMA
Department of Physical Education and Athletics
UNIVERSITY, ALABAMA 35486

February 13, 1965

PAUL W. BRYANT
Athletic Director &
Head Football Coach

Mr. Kemp W. Duncan
Carson Blvd
Sparta, North Carolina

Dear Mr. Duncan:

The family and I wish to thank you for the delicious ham.  You were so thoughtful to send it and we appreciate your kindness.

Best wishes and kind regards.

Sincerely,

Paul Bryant
Director of Athletics

PWB:mp

[P.65]
990.063.081

Just a little token of appreciation for what you are doing for my son.  Hope you and your family enjoy it.

Sincerely,
Kemp W. Duncan,

Sparta, N. Car.

*The Crimson Tide*

## LETTERS

Coach Bryant received thousands of written correspondence, including these two examples: one is from eight year old Mike Davis requesting an autograph and the other is a thank you note which included a gift to Coach Bryant from Kemp Duncan. Kemp Duncan is the father of Bama's tackle Jerry Duncan. Included is Coach Bryant's response.

990.063.024
[1965]

Dear Coach Bryant.
I would like very much to have your Autograph. I am eight years old. I am in the third grade at Ann Cathey School. I play foot ball. I would love to play foot ball for you someday. I lister to all Alabama games on radio. And if they are on T.V. I watch them. Santa Claus brought me a foot ball. Suit for Christmas last. I'll be pulling for you Saturday night. My daddy will be at the game. I will listen to it on the radio.

yea Bama

Thanks Very Much
Mike Davis
715 Delilah St
Gadsden. Ala

Thanks Very Much for taking the time to read our boys letter
Mrs Coy Davis

990.063.025

The University of Alabama
Department of Athletics
University, Alabama 35486

National Football Champions
1961 and 1964

October 1, 1965

Mr. Mike Davis
715 Delilah Street
Gadsden, Alabama

Dear Mike:

I enjoyed hearing from you.  It is good to know that you are interested in football and our team.

Thanks, and good luck.

Sincerely,

Paul Bryant

PWB/mp

*The Crimson Tide*

WRITTEN CORRESPONDENCE
TO COACH BRYANT

57

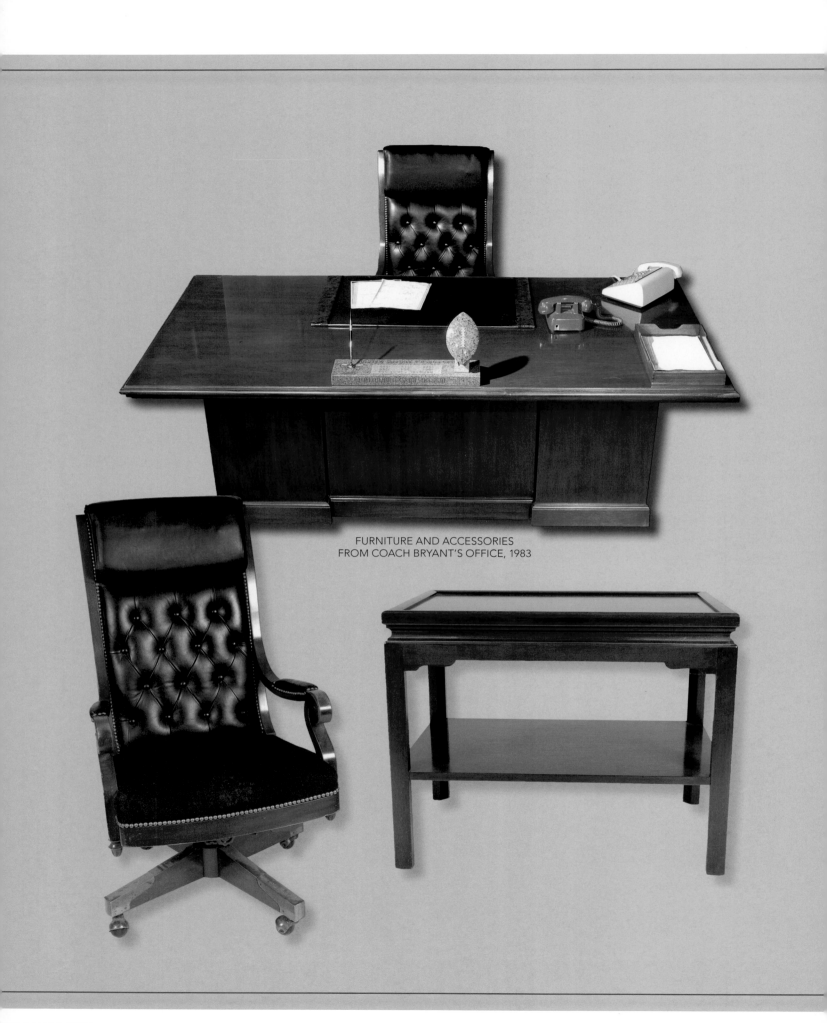

FURNITURE AND ACCESSORIES
FROM COACH BRYANT'S OFFICE, 1983

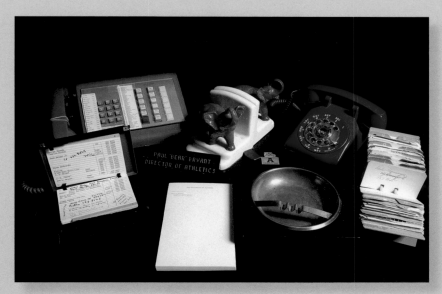

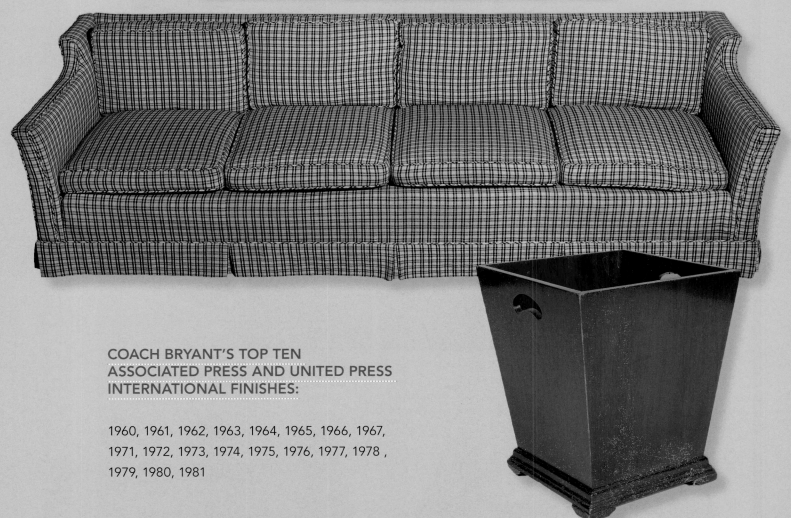

**COACH BRYANT'S TOP TEN
ASSOCIATED PRESS AND UNITED PRESS
INTERNATIONAL FINISHES:**

1960, 1961, 1962, 1963, 1964, 1965, 1966, 1967,
1971, 1972, 1973, 1974, 1975, 1976, 1977, 1978 ,
1979, 1980, 1981

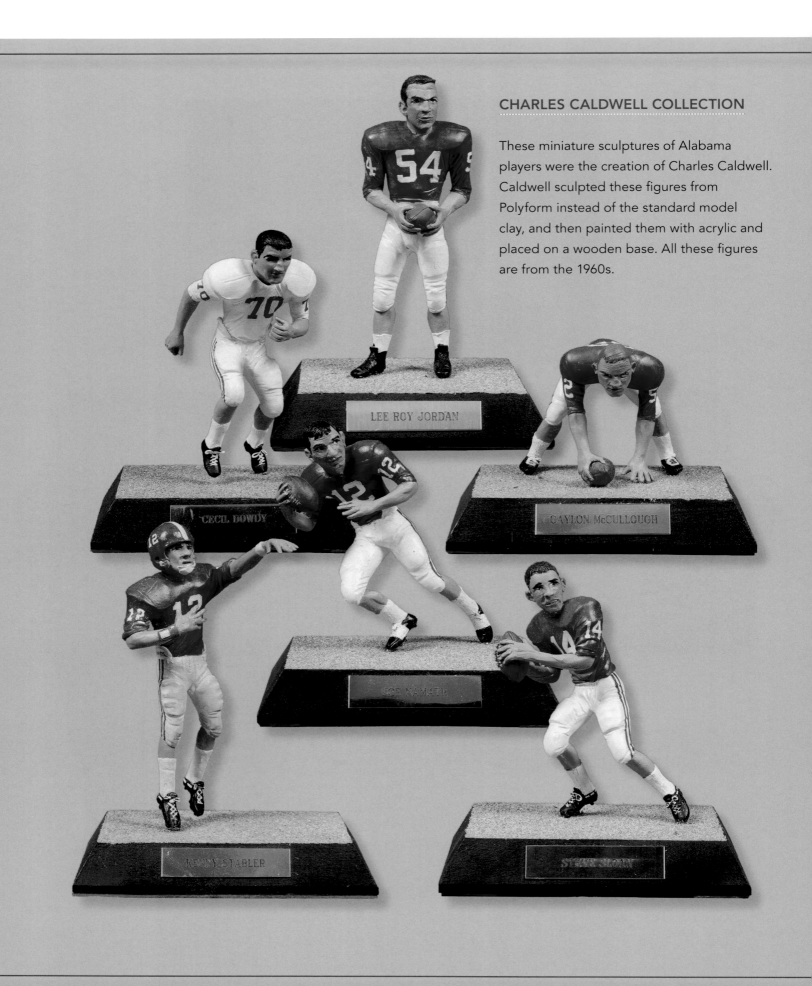

CHARLES CALDWELL COLLECTION

These miniature sculptures of Alabama players were the creation of Charles Caldwell. Caldwell sculpted these figures from Polyform instead of the standard model clay, and then painted them with acrylic and placed on a wooden base. All these figures are from the 1960s.

LEE ROY JORDAN

CECIL DOWDY

GAYLON McCULLOUGH

JOE NAMATH

KENNY STABLER

STEVE SLOAN

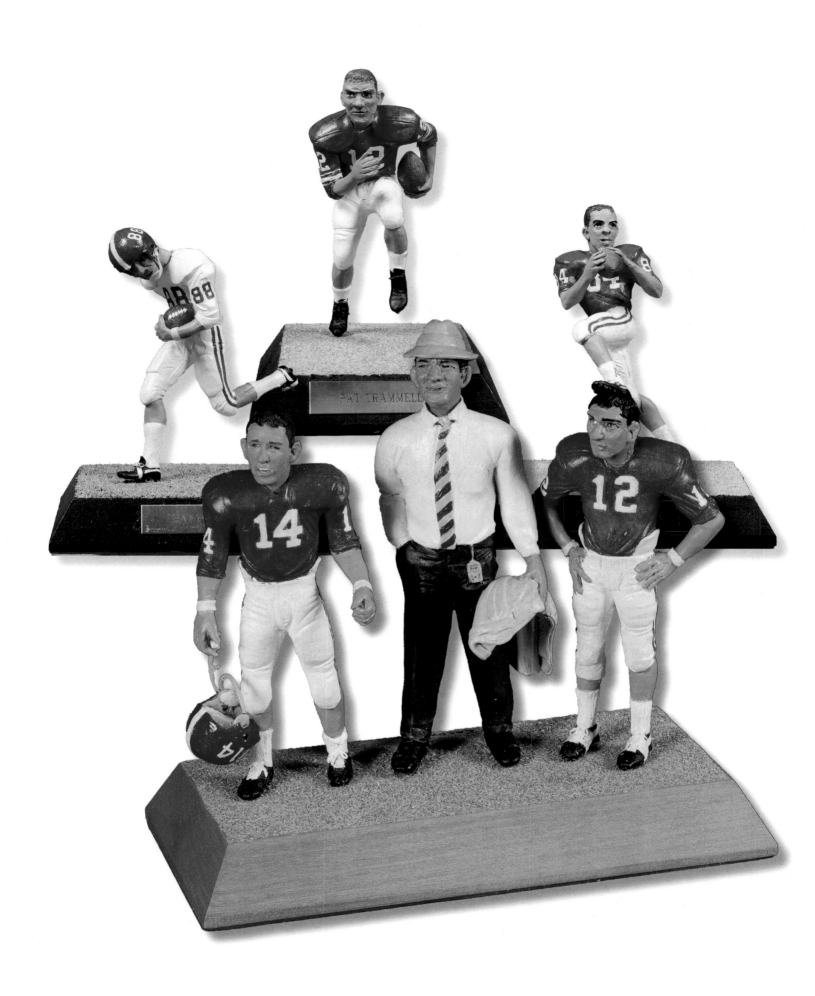

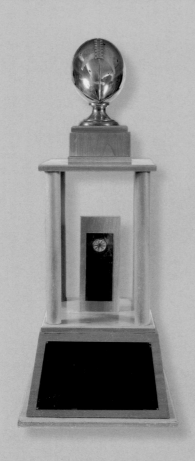
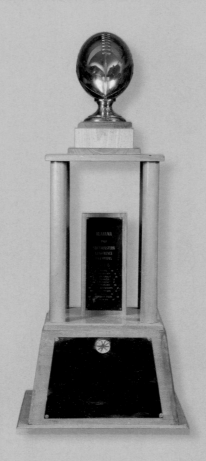
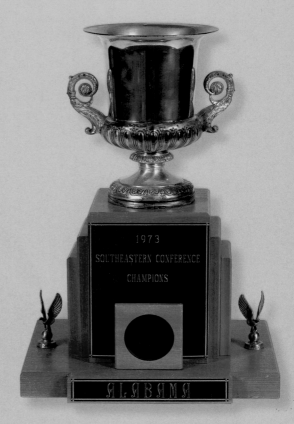

## ALABAMA'S SEC TITLES:

1933, 1934, 1937, 1945,
1953, 1961, 1964, 1965, 1966,
1971, 1972, 1973, 1974, 1975,
1977, 1978, 1979, 1981, 1989,
1992, 1999, 2009, 2012

NINE OF COACH BRYANT'S
13 SEC CHAMPIONSHIP TROPHIES

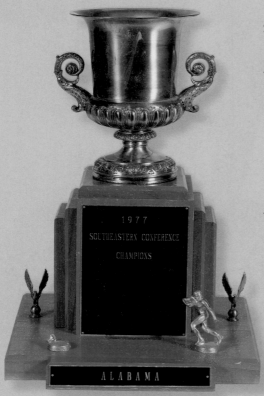
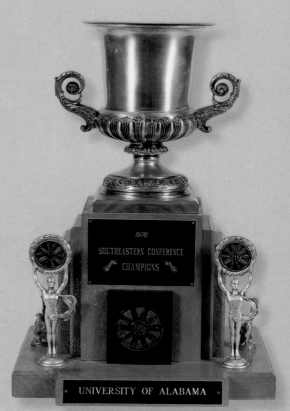

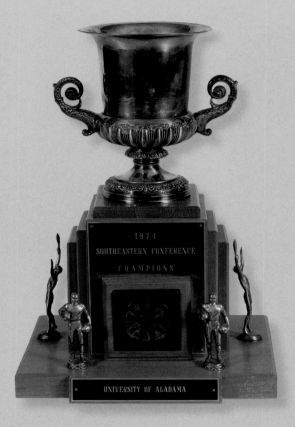

1974
SOUTHEASTERN CONFERENCE
CHAMPIONS

UNIVERSITY OF ALABAMA

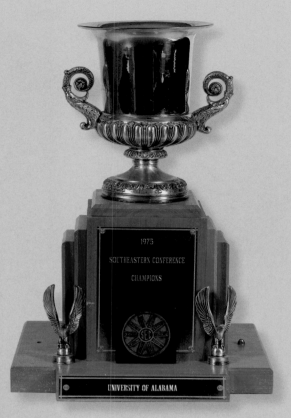

1975
SOUTHEASTERN CONFERENCE
CHAMPIONS

UNIVERSITY OF ALABAMA

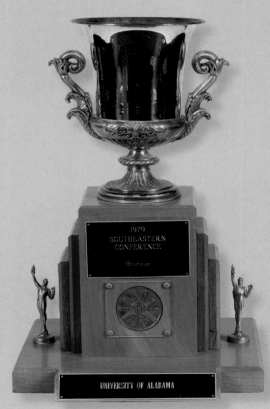

1979
SOUTHEASTERN
CONFERENCE
Champion

UNIVERSITY OF ALABAMA

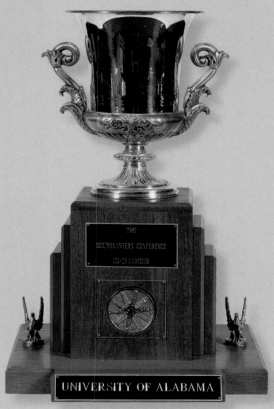

1981
SOUTHEASTERN CONFERENCE
CO-CHAMPIONS

UNIVERSITY OF ALABAMA

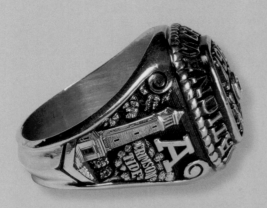
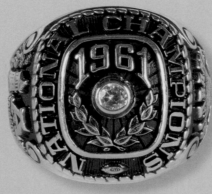
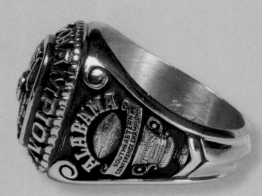

### ALABAMA'S NATIONAL TITLES:

1925, 1926, 1930, 1934, 1941, 1961,
1964, 1965, 1973, 1978, 1979,
1992, 2009, 2011, 2012

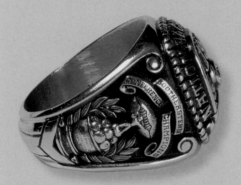
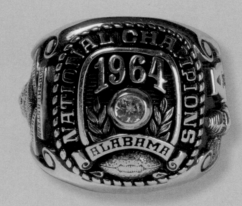
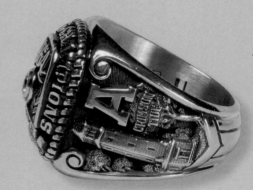

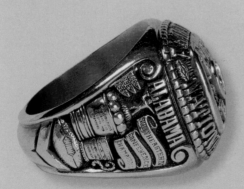
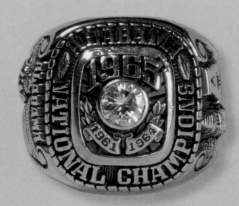
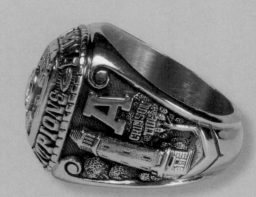

NATIONAL CHAMPIONSHIP RINGS
FROM THE BRYANT ERA

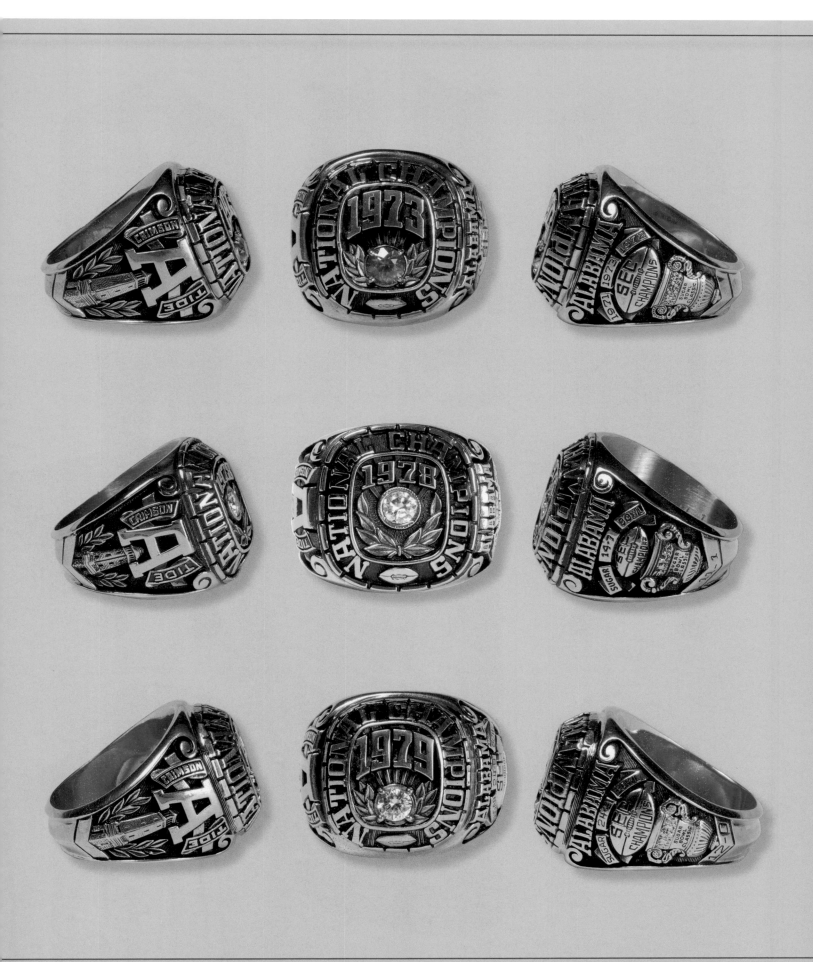

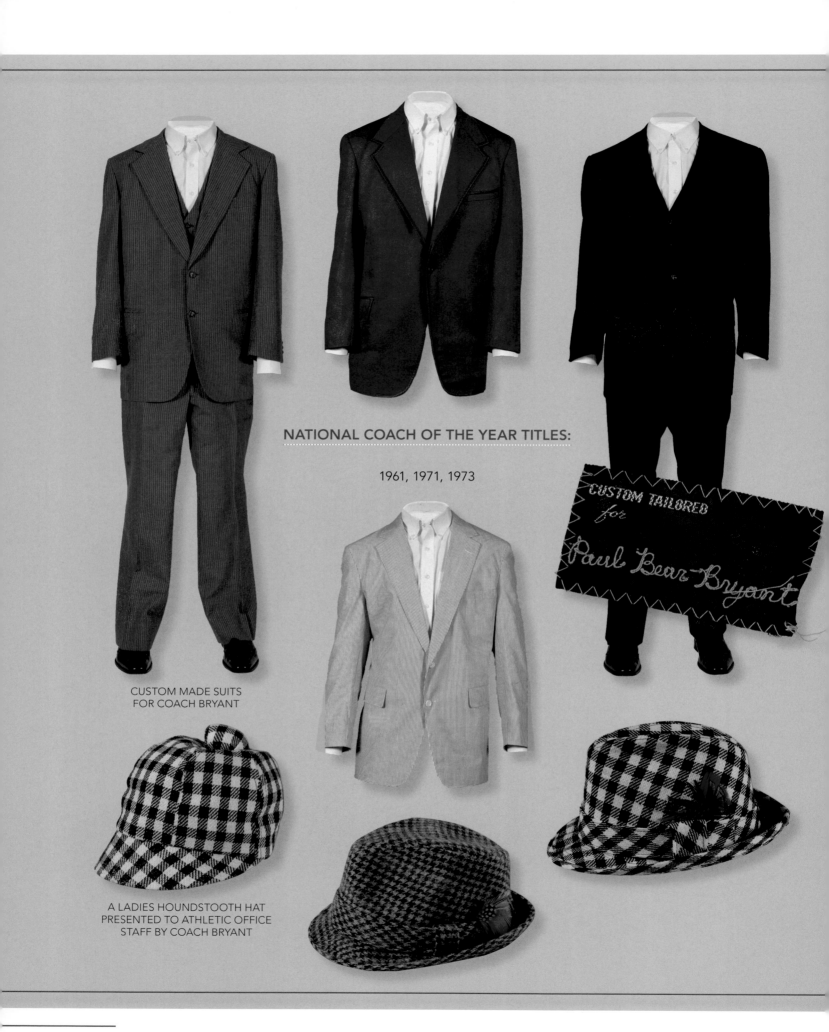

NATIONAL COACH OF THE YEAR TITLES:

1961, 1971, 1973

CUSTOM TAILORED for Paul Bear Bryant

CUSTOM MADE SUITS FOR COACH BRYANT

A LADIES HOUNDSTOOTH HAT PRESENTED TO ATHLETIC OFFICE STAFF BY COACH BRYANT

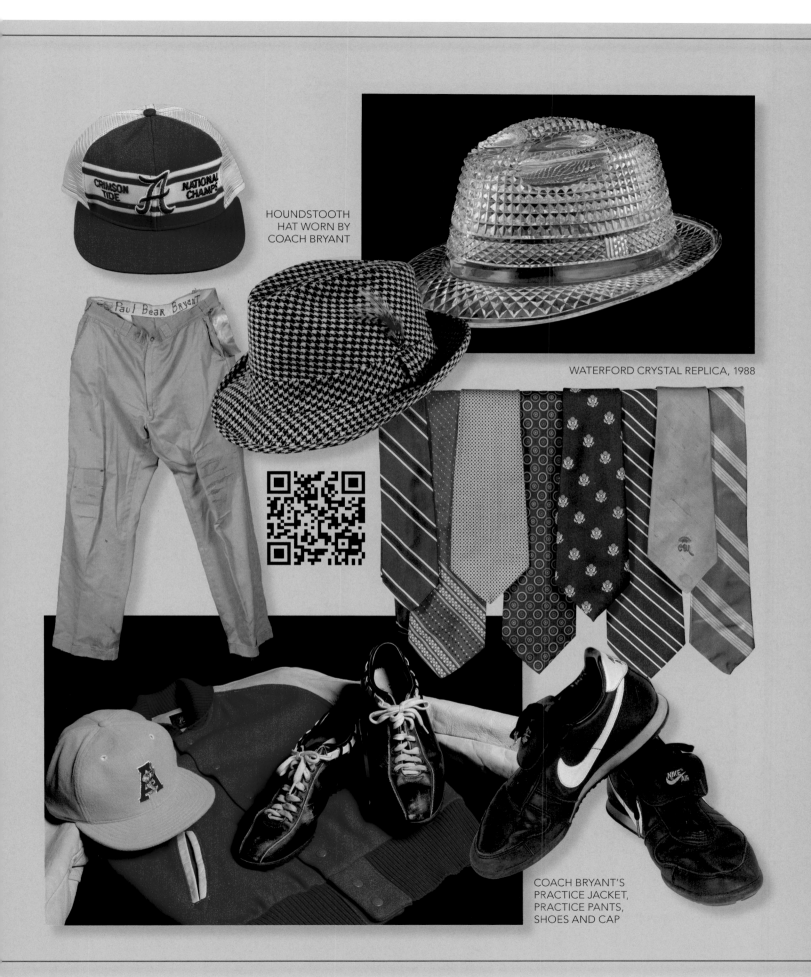

HOUNDSTOOTH HAT WORN BY COACH BRYANT

WATERFORD CRYSTAL REPLICA, 1988

COACH BRYANT'S PRACTICE JACKET, PRACTICE PANTS, SHOES AND CAP

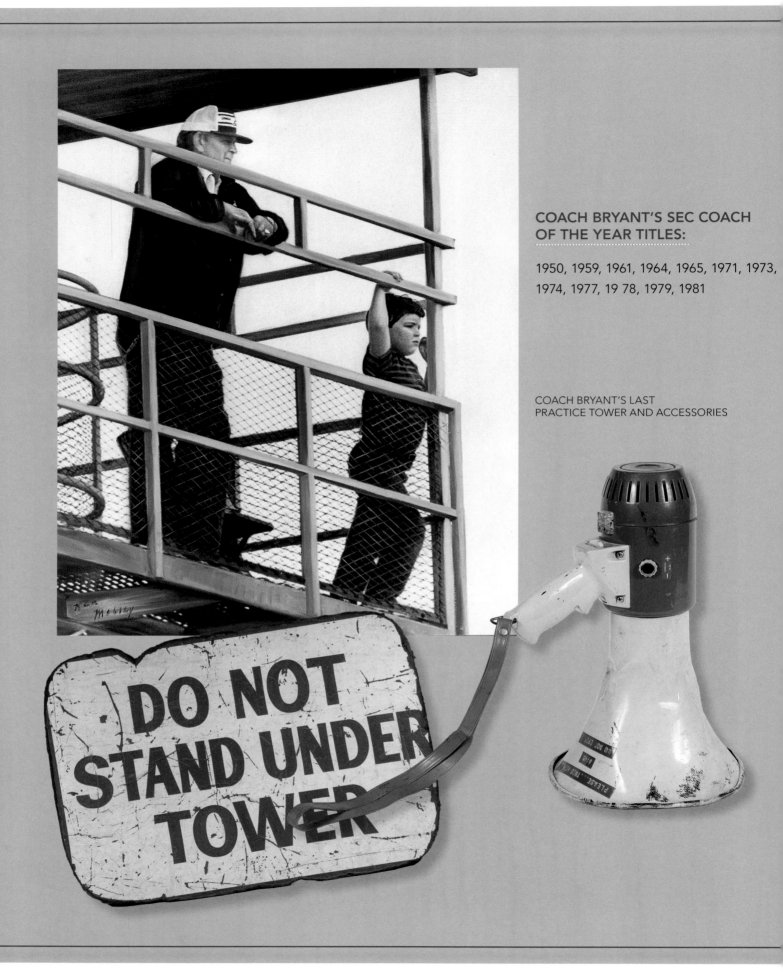

**COACH BRYANT'S SEC COACH OF THE YEAR TITLES:**

1950, 1959, 1961, 1964, 1965, 1971, 1973, 1974, 1977, 19 78, 1979, 1981

COACH BRYANT'S LAST
PRACTICE TOWER AND ACCESSORIES

DO NOT STAND UNDER TOWER

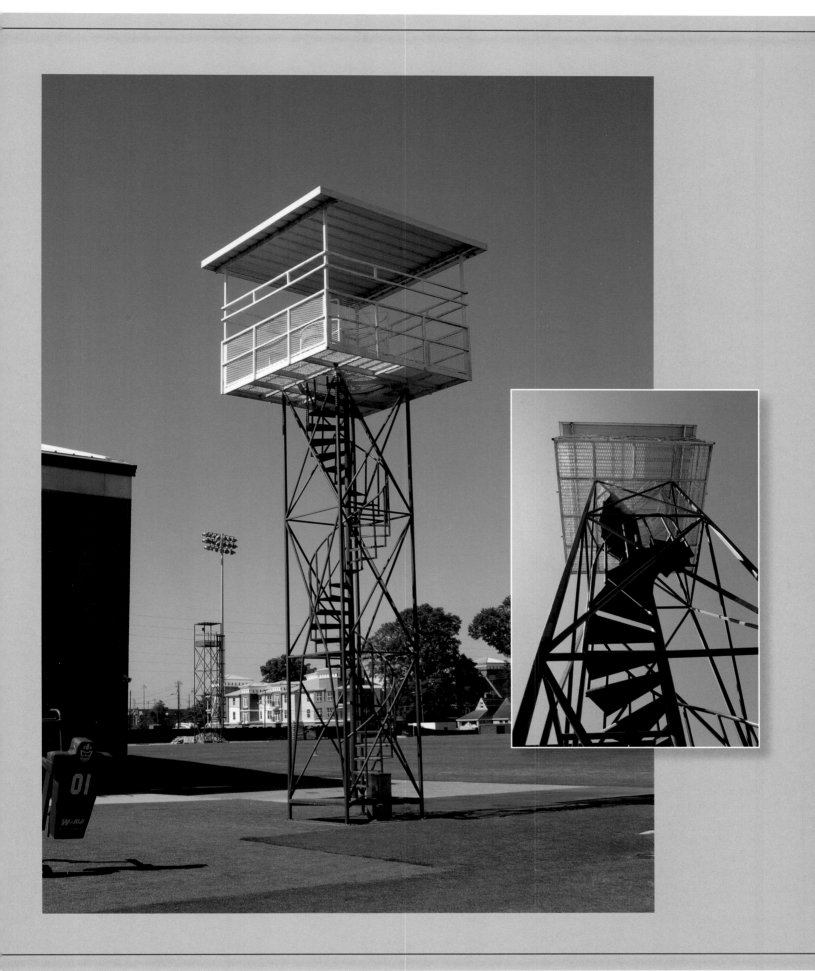

# SHIFTING TIDES

## 1968–1972

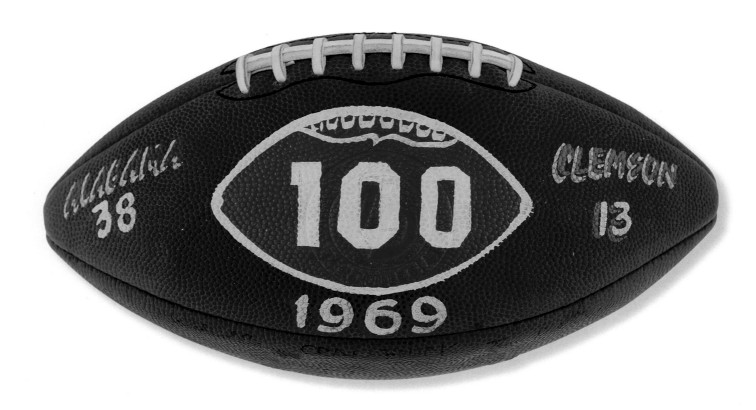

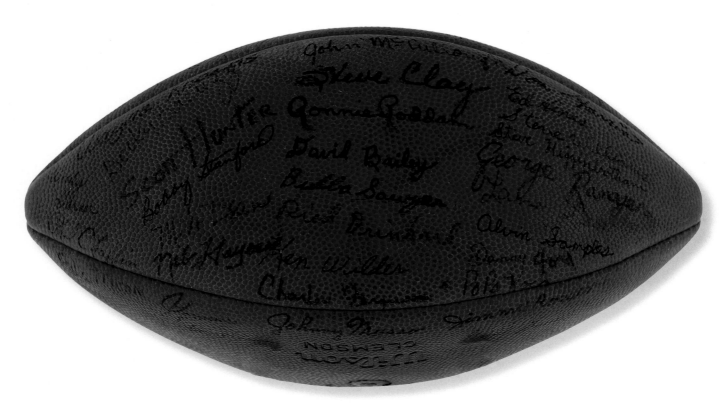

## CENTENNIAL CELEBRATION

In honor of the very first collegiate football game in 1869, the college football world celebrated its anniversary during the 1969 season. Rutgers University and Princeton University played in the very first intercollegiate football game. To the modern observer that 1869 game would look closer to soccer than football.

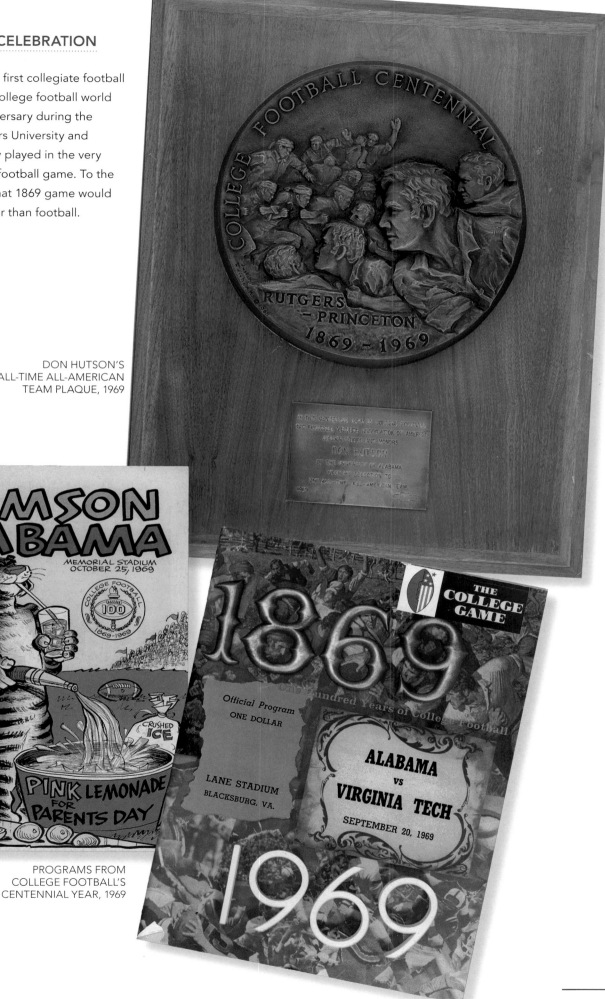

DON HUTSON'S
ALL-TIME ALL-AMERICAN
TEAM PLAQUE, 1969

PROGRAMS FROM
COLLEGE FOOTBALL'S
CENTENNIAL YEAR, 1969

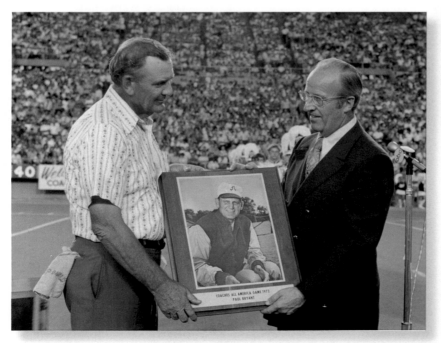

COACHES ALL AMERICA GAME 1972
PAUL BRYANT

## IT'S THE BEGINNING OF A NEW DAY

The nighttime 1971 season opener between the Crimson Tide and the Trojans of Southern California might be the most important game in school history, for two very big reasons. The contest was the first time in Crimson Tide football history that an African American played for Alabama. John Mitchell, a junior college transfer from Mobile started the game for Alabama at defensive end. Wilbur Jackson, who was Alabama's first African American football signee, also played during the 1971 season.

A side note, Wendell Hudson was an All-America basketball player during the 1972 season, he was Bama's first African American scholarship athlete.

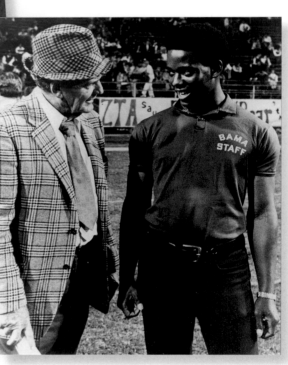

COACH BRYANT AND JOHN MITCHELL, 1973

"I've read a lot about successful men, They don't do it alone. It always takes a team."

— *Coach Bryant*

PLAQUE PRESENTED TO COACH BRYANT ALONG WITH A PHOTOGRAPH OF COACH BRYANT RECEIVING THE AWARD, 1972

The second important event that occurred during the 1971 USC game was the introduction of a new offense scheme for Alabama: The Wishbone.

During the spring and summer of 1971, Bryant quietly switched from a pro-style offense to the wishbone set. Alabama surprised the Trojans with the run oriented offense taking an early lead and holding on for a 17-10 victory. Those two historic moves by Coach Bryant led Alabama into a decade of dominance unmatched in college football.

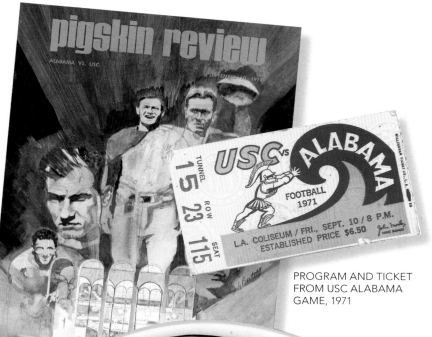

PROGRAM AND TICKET FROM USC ALABAMA GAME, 1971

WISHBONE DIAGRAM FROM COACH BRYANT'S PLAYBOOK, 1971

200
ALABAMA 17
SOU. CAL 10
SEPT. 10, 1971

FROM YOUR 1971 U.A. TEAM

MARBLE TROPHY PRESENTED TO COACH BRYANT BY PLAYERS,1971

SEPT. 10, 1971
ALABAMA 17, U.S.C. 10
200th WIN
COACH PAUL BRYANT

HAPPINESS IS BEING A FRIEND OF JOHN McKAY

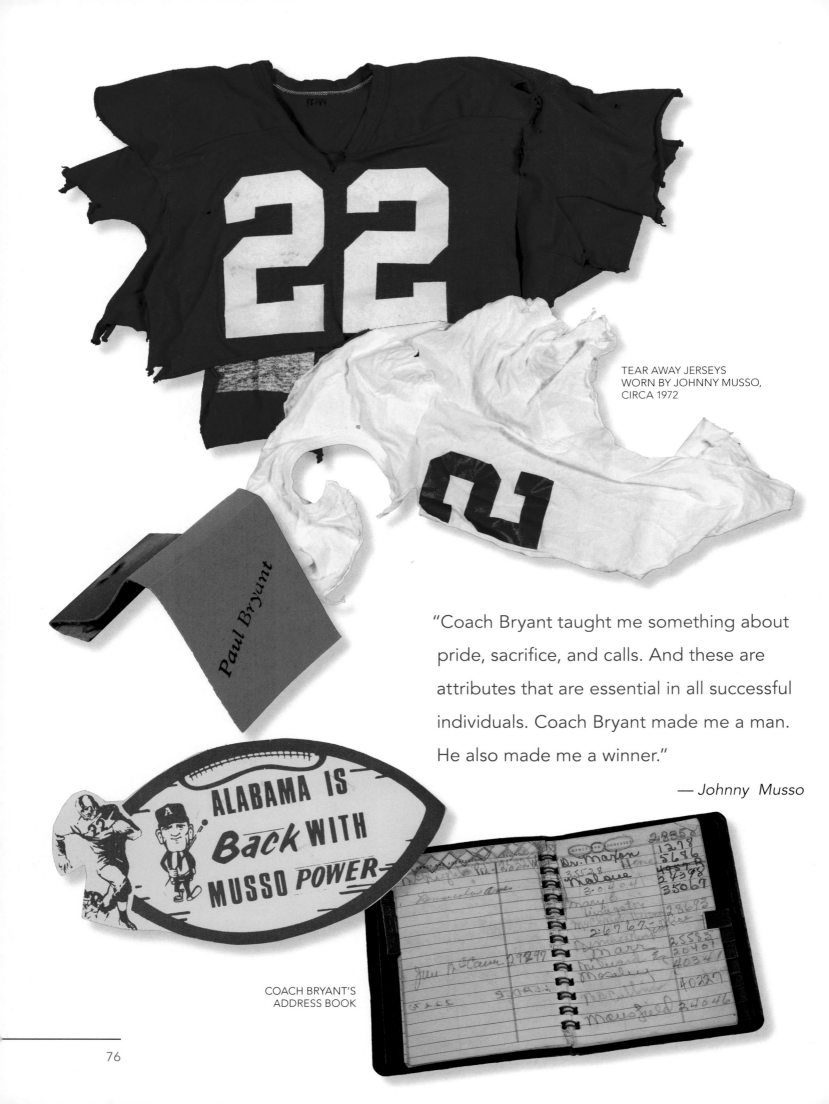

TEAR AWAY JERSEYS
WORN BY JOHNNY MUSSO,
CIRCA 1972

Paul Bryant

"Coach Bryant taught me something about pride, sacrifice, and calls. And these are attributes that are essential in all successful individuals. Coach Bryant made me a man. He also made me a winner."

— Johnny Musso

ALABAMA IS Back WITH MUSSO POWER

COACH BRYANT'S
ADDRESS BOOK

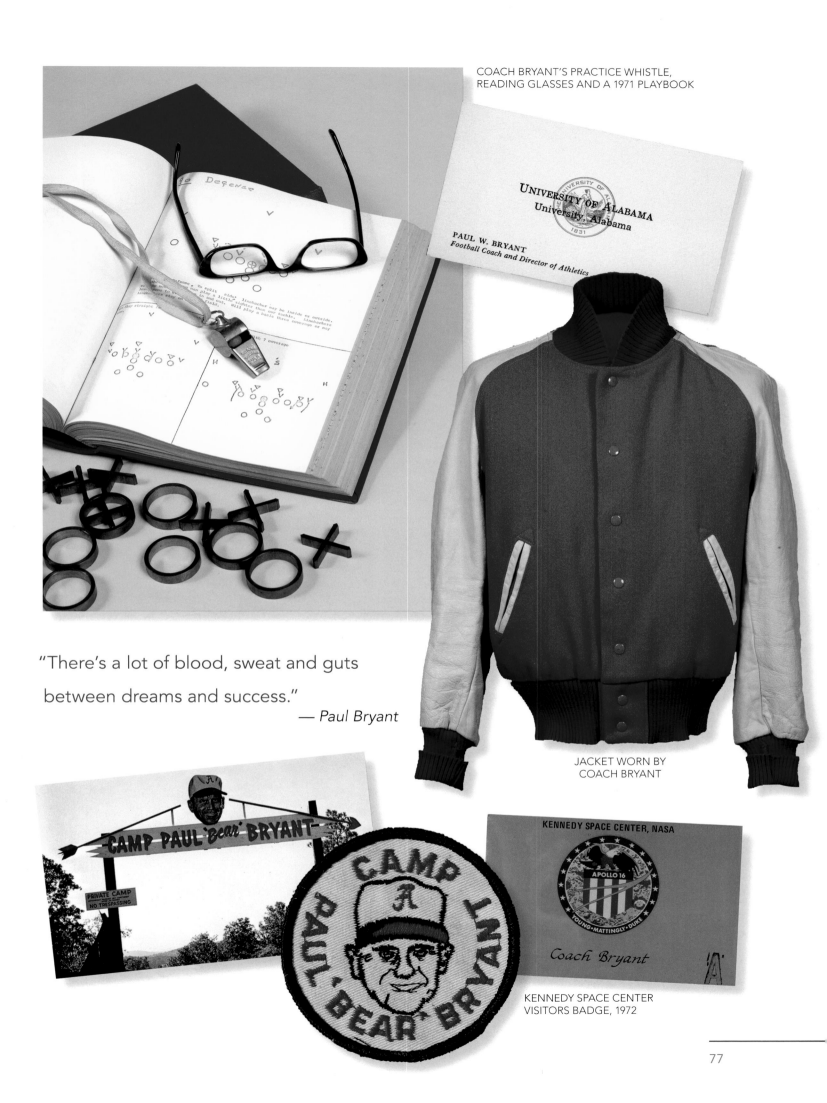

COACH BRYANT'S PRACTICE WHISTLE, READING GLASSES AND A 1971 PLAYBOOK

UNIVERSITY OF ALABAMA
University, Alabama

PAUL W. BRYANT
Football Coach and Director of Athletics

"There's a lot of blood, sweat and guts between dreams and success."
— *Paul Bryant*

JACKET WORN BY
COACH BRYANT

KENNEDY SPACE CENTER, NASA

APOLLO 16
YOUNG · MATTINGLY · DUKE

*Coach Bryant*

KENNEDY SPACE CENTER
VISITORS BADGE, 1972

# DECADE OF DOMINANCE

## 1972–1980

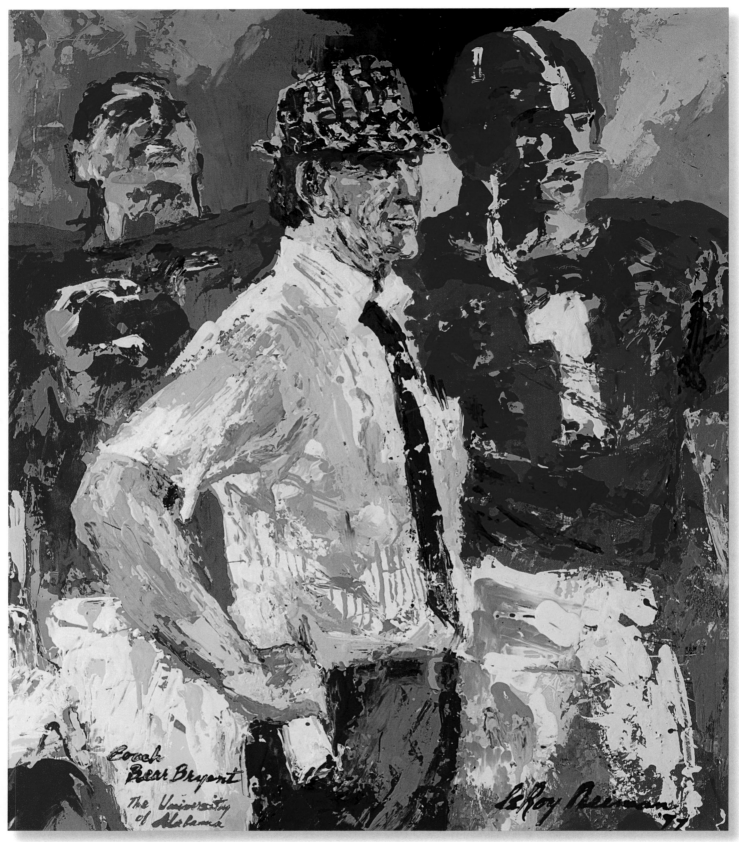

LEROY NIEMAN'S "BEAR BRYANT," 1977

## DYNASTY

When sports historians talk about college football dynasties, they will have to include Alabama in the 1970s. The Tide played for six national championships winning three during that period. They finished in the AP top 10 nine times and the top 5 seven times. Bama won eight SEC championships, and finished the decade with a total of 103 victories.

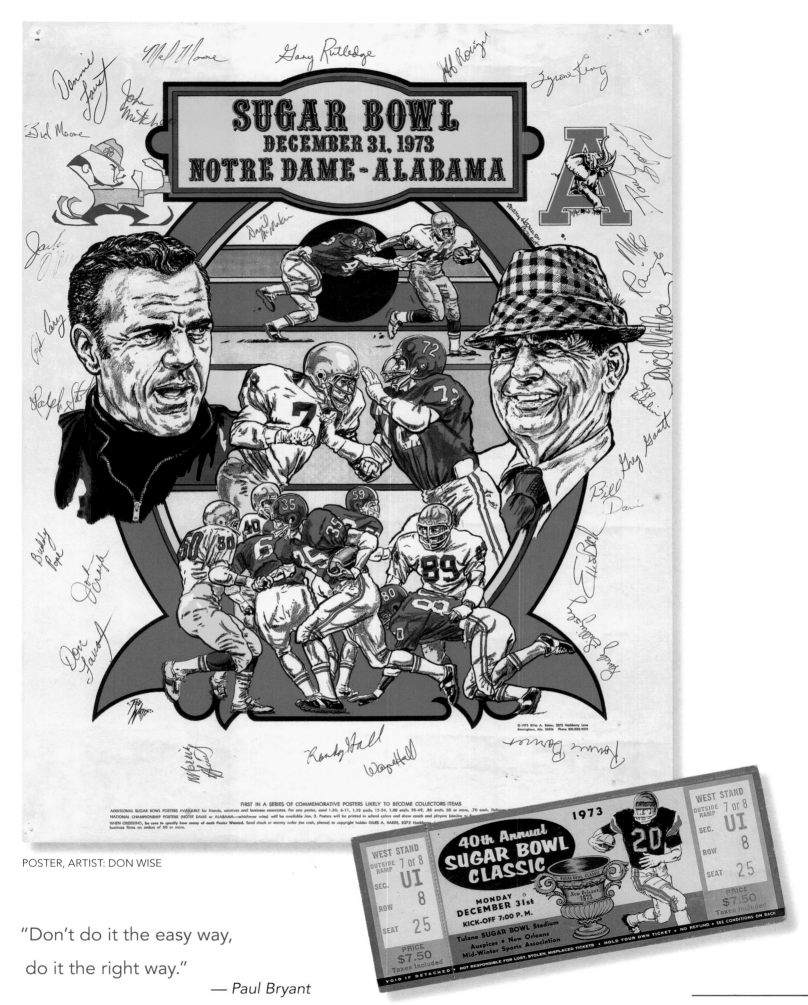

POSTER, ARTIST: DON WISE

"Don't do it the easy way,

do it the right way."

— *Paul Bryant*

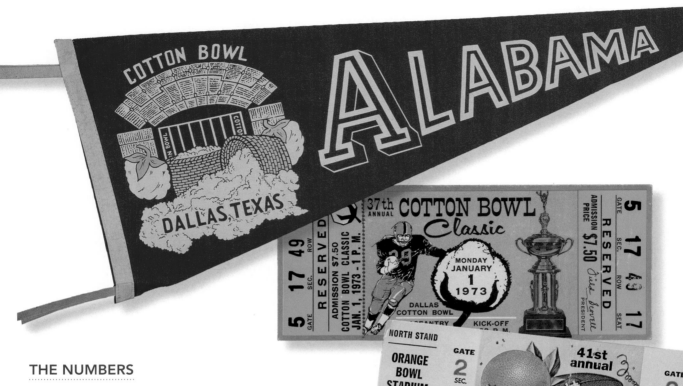

## THE NUMBERS

By the 1972 season Bama's wishbone was a well-oiled offensive machine. The Crimson Tide averaged 306 yards and 36 points per game. The following year was just as impressive, averaging 366 yards a game, and scoring 40 points per game.

As we all know, offense sells the tickets, but it's the defense that wins championships. Alabama's defense was just as solid as the offense, giving up an average of only 10.2 points per game, and a measly 3.6 yards per play during the decade. Alabama's defensive squad finished every year of the 70s in the NCAA's top 10 defenses, and led the nation in 1975 & 1979.

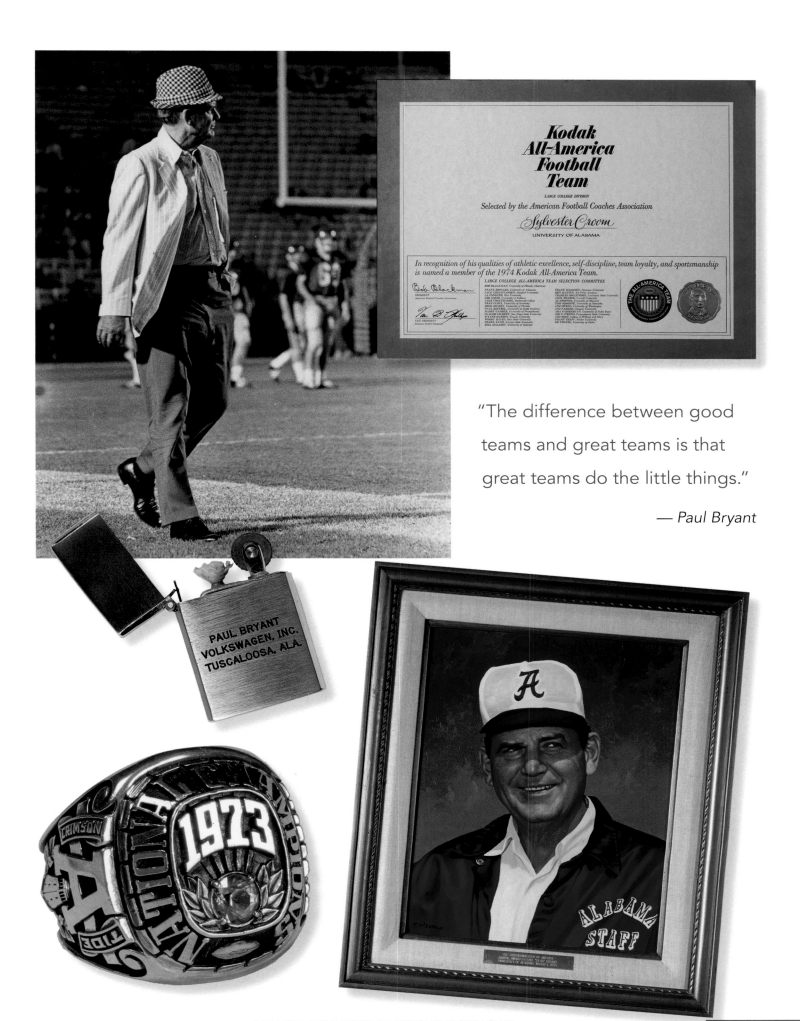

Kodak
All-America
Football
Team

LARGE COLLEGE DIVISION

Selected by the American Football Coaches Association

Sylvester Croom

UNIVERSITY OF ALABAMA

In recognition of his qualities of athletic excellence, self-discipline, team loyalty, and sportsmanship is named a member of the 1974 Kodak All-America Team.

"The difference between good teams and great teams is that great teams do the little things."

— *Paul Bryant*

PAUL BRYANT
VOLKSWAGEN, INC.
TUSCALOOSA, ALA.

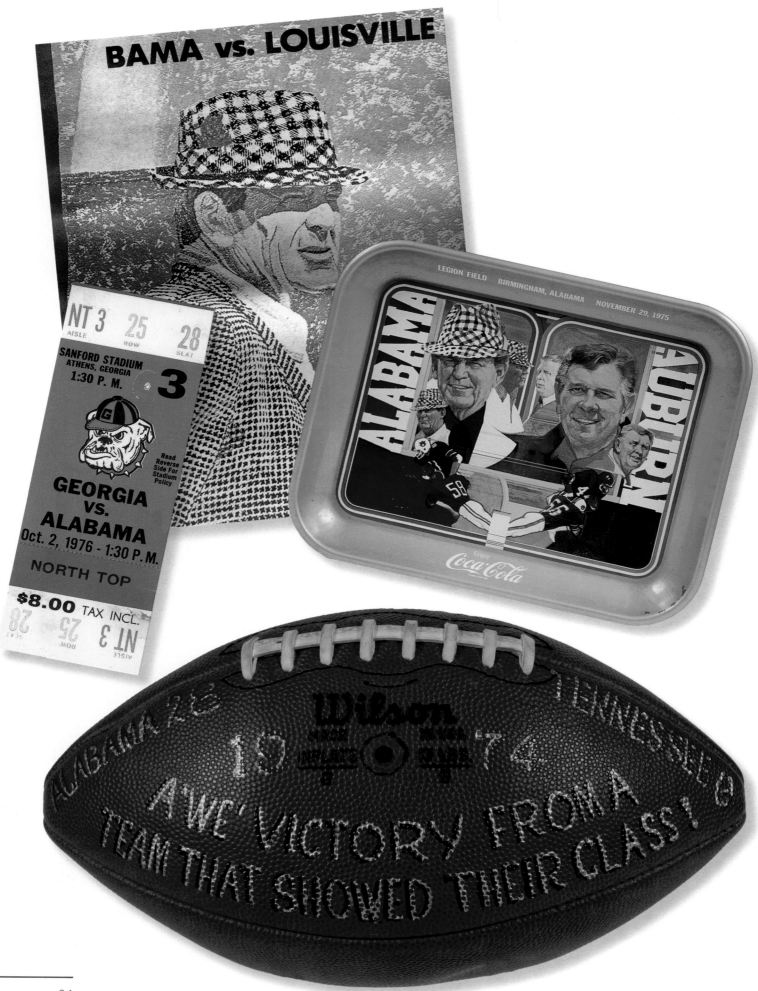

BAMA vs. LOUISVILLE

NT 3   25   28
AISLE   ROW   SEAT

SANFORD STADIUM
ATHENS, GEORGIA
1:30 P. M.

3

Read
Reverse
Side For
Stadium
Policy

GEORGIA
VS.
ALABAMA

Oct. 2, 1976 - 1:30 P.M.

NORTH TOP

$8.00 TAX INCL.

LEGION FIELD   BIRMINGHAM, ALABAMA   NOVEMBER 29, 1975

ALABAMA   AUBURN

Enjoy Coca-Cola

Wilson

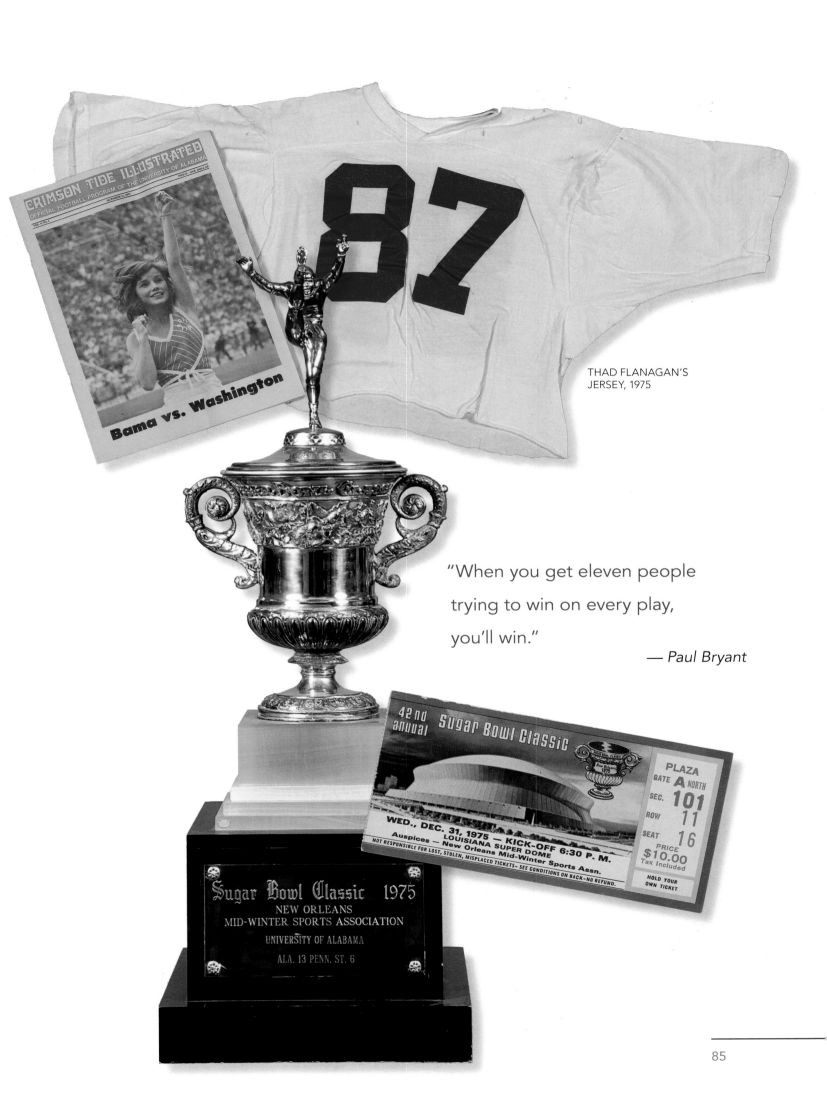

CRIMSON TIDE ILLUSTRATED
OFFICIAL FOOTBALL PROGRAM OF THE UNIVERSITY OF ALABAMA
PRICE: ONE DOLLAR
Bama vs. Washington

THAD FLANAGAN'S
JERSEY, 1975

"When you get eleven people
trying to win on every play,
you'll win."

— Paul Bryant

42nd annual Sugar Bowl Classic

PLAZA
GATE A NORTH
SEC. 101
ROW 11
SEAT 16
PRICE
$10.00
Tax Included

WED., DEC. 31, 1975 — KICK-OFF 6:30 P. M.
LOUISIANA SUPER DOME
Auspices — New Orleans Mid-Winter Sports Assn.
NOT RESPONSIBLE FOR LOST, STOLEN, MISPLACED TICKETS- SEE CONDITIONS ON BACK-NO REFUND.

HOLD YOUR
OWN TICKET

Sugar Bowl Classic 1975
NEW ORLEANS
MID-WINTER SPORTS ASSOCIATION
UNIVERSITY OF ALABAMA
ALA. 13 PENN. ST. 6

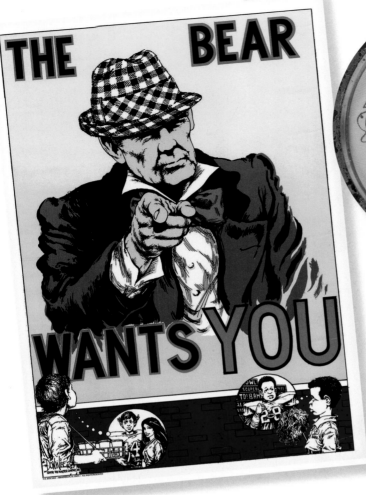

WRISTWATCH GIVEN BY COACH
BRYANT TO HIS GRANDSON

'THE BEAR WANTS YOU'
POSTER, ARTIST: DON WISE

"… Tradition is the thing that sustains us. Tradition

is that which allows us to prevail in ways that we could

not other wise." — *University President David Matthews*

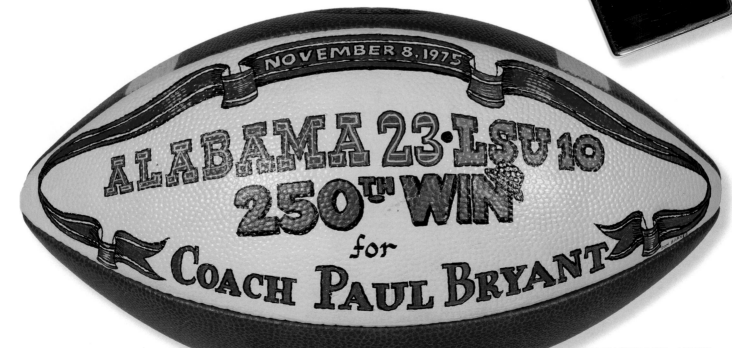

GAME USED BALL, ARTIST
DON BARNES

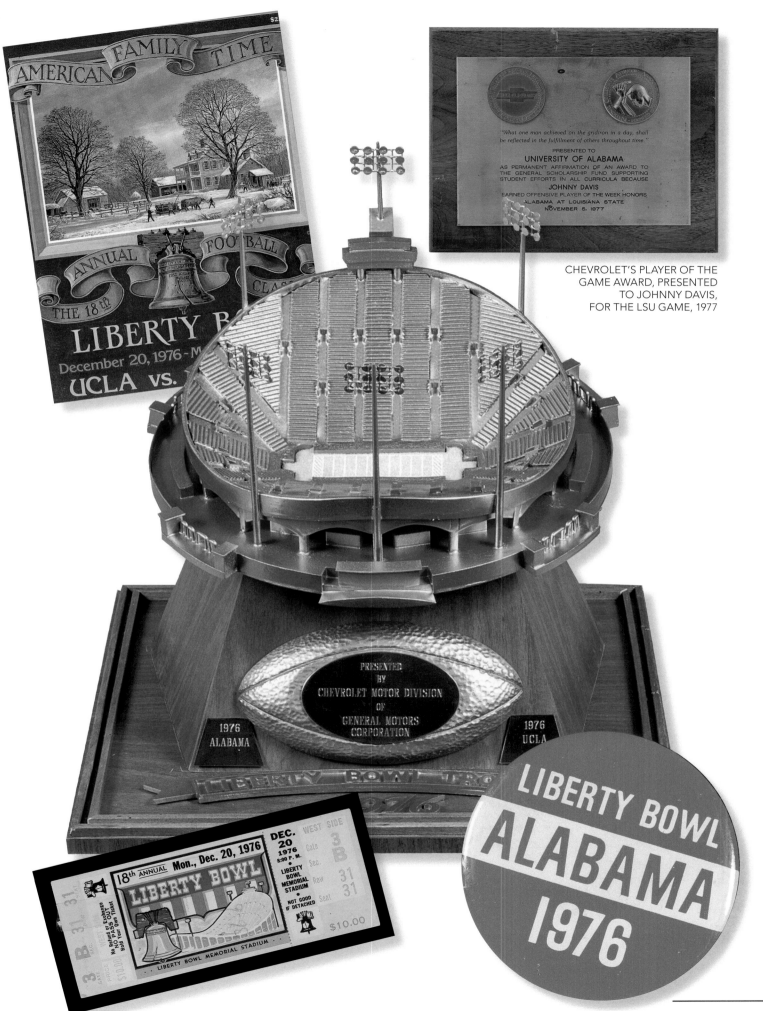

AMERICAN FAMILY TIME

ANNUAL FOOTBALL CLASSIC

THE 18th

LIBERTY B

December 20, 1976 - M

UCLA vs.

"What one man achieved on the gridiron in a day, shall be reflected in the fulfillment of others throughout time."

PRESENTED TO

**UNIVERSITY OF ALABAMA**

AS PERMANENT AFFIRMATION OF AN AWARD TO THE GENERAL SCHOLARSHIP FUND SUPPORTING STUDENT EFFORTS IN ALL CURRICULA BECAUSE

**JOHNNY DAVIS**

EARNED OFFENSIVE PLAYER OF THE WEEK HONORS ALABAMA AT LOUISIANA STATE NOVEMBER 5, 1977

CHEVROLET'S PLAYER OF THE GAME AWARD, PRESENTED TO JOHNNY DAVIS, FOR THE LSU GAME, 1977

PRESENTED BY CHEVROLET MOTOR DIVISION OF GENERAL MOTORS CORPORATION

1976 ALABAMA

1976 UCLA

LIBERTY BOWL TRO 1976

18th ANNUAL **LIBERTY BOWL** XIII

LIBERTY BOWL MEMORIAL STADIUM

Mon., Dec. 20, 1976

DEC. 20 1976 8:00 P.M.

WEST SIDE

Gate **3**

Sec. **B**

LIBERTY BOWL MEMORIAL STADIUM

Row **31**

NOT GOOD IF DETACHED

Seat **31**

$10.00

LIBERTY BOWL **ALABAMA** 1976

87

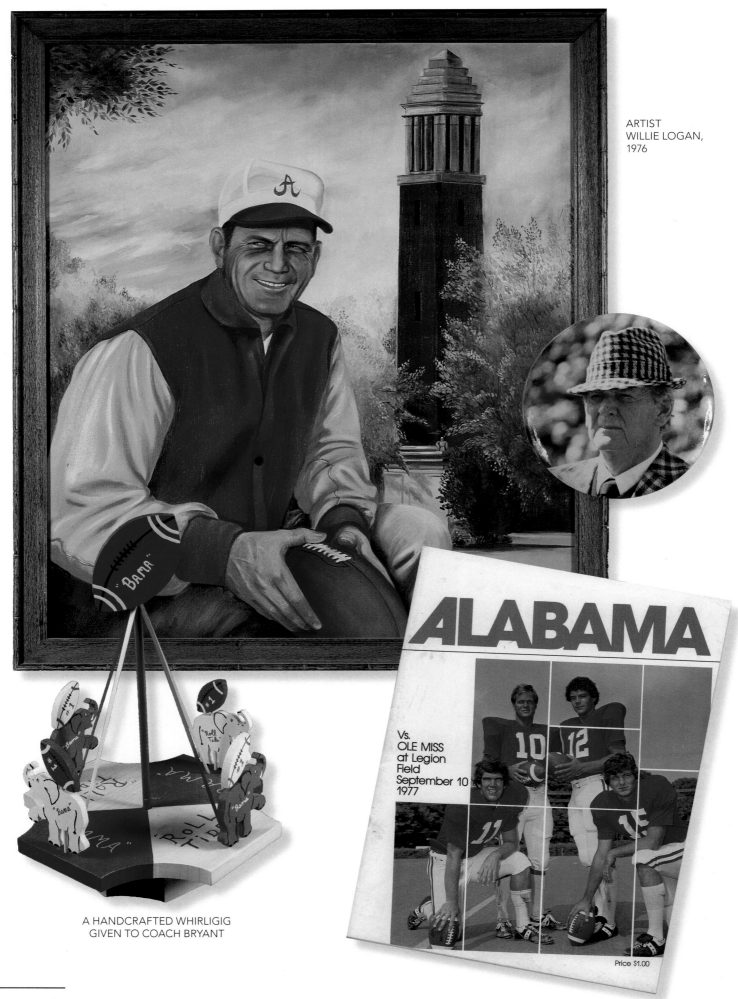

ARTIST
WILLIE LOGAN,
1976

A HANDCRAFTED WHIRLIGIG
GIVEN TO COACH BRYANT

ALABAMA

Vs.
OLE MISS
at Legion
Field
September 10
1977

Price $1.00

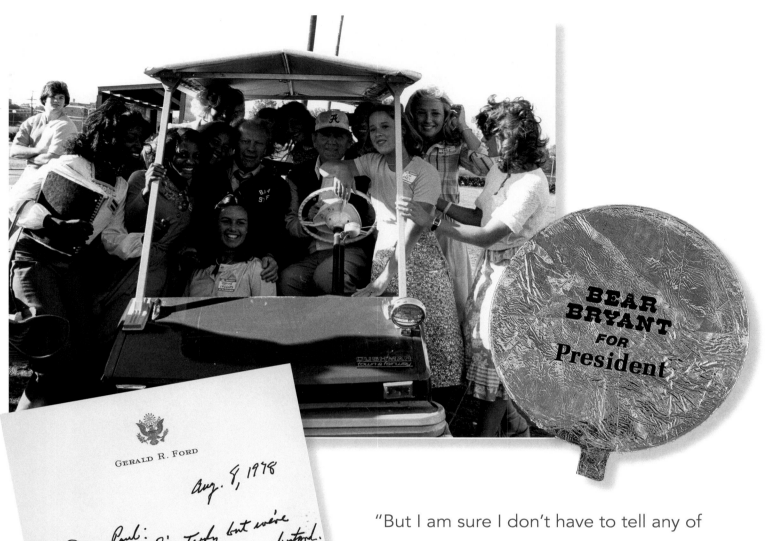

GERALD R. FORD

Aug. 9, 1978

Dear Paul:

I'm tardy but we've been busy as I hope you understand.

A fine group of young men with an outstanding coaching staff and led by a damn good "boss."

Good luck for a fine season. I really enjoyed my visit to Alabama.

Best wishes, Jerry Ford

P.S. Photos are on their way separately. JF

RANCHO MIRAGE
CALIFORNIA 92270

Mr. Paul W. Bryant
Athletic Director & Football Coach
University of Alabama.
Tuscaloosa, Ala.

BEAR BRYANT FOR President

"But I am sure I don't have to tell any of you, in this audience particularly, the problems of being an athletic director or head coach. For instance, I see my good friend Bear Bryant down here. I was talking to Bear and he said, "We both had the very same experience on New Year's Day." I said, "How is that possible? I was skiing and you were at the Orange Bowl." He said, "That is what I mean. We both hit the top, and after that it was all downhill."

— *President Gerald Ford at the NCAA annual awards luncheon, January 7, 1975*

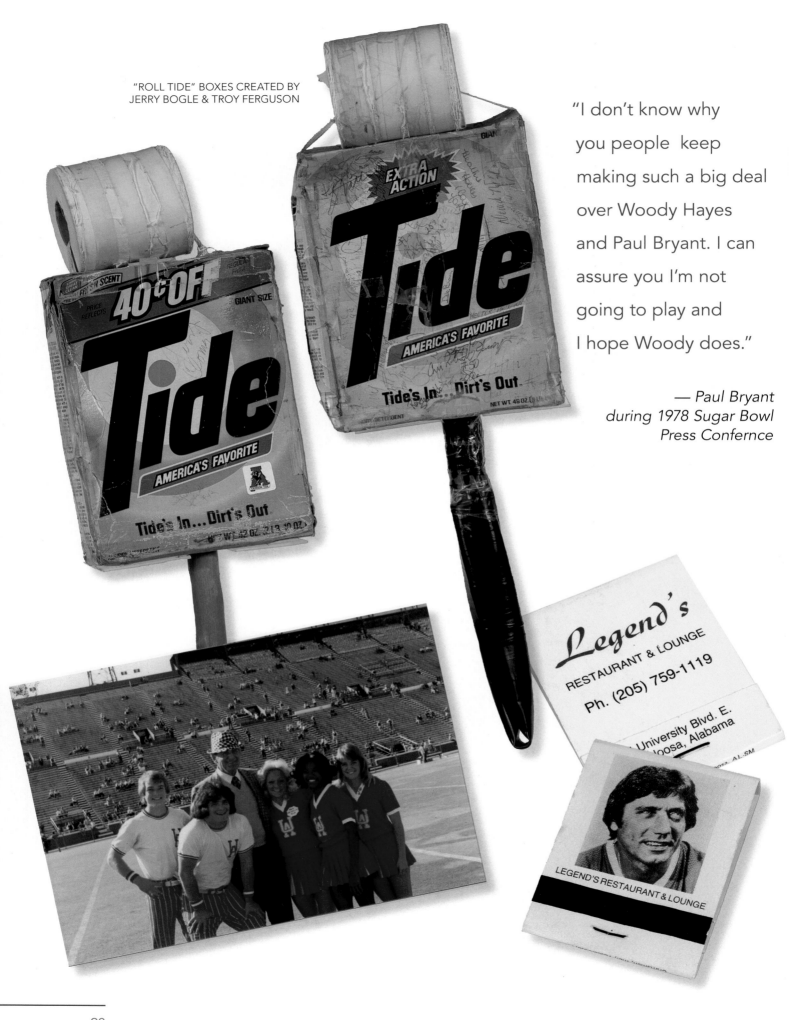

"ROLL TIDE" BOXES CREATED BY
JERRY BOGLE & TROY FERGUSON

"I don't know why you people keep making such a big deal over Woody Hayes and Paul Bryant. I can assure you I'm not going to play and I hope Woody does."

— Paul Bryant
during 1978 Sugar Bowl
Press Confernce

*Legend's*
RESTAURANT & LOUNGE
Ph. (205) 759-1119

University Blvd. E.
loosa, Alabama

LEGEND'S RESTAURANT & LOUNGE

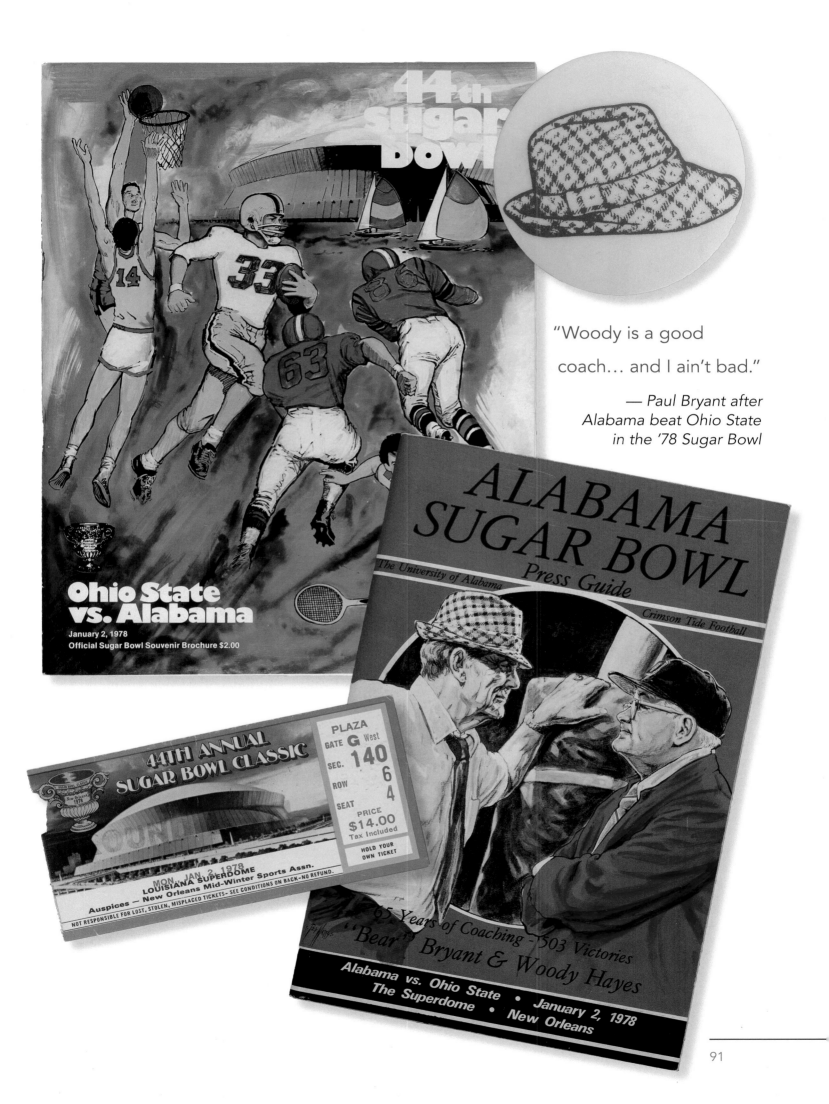

"Woody is a good coach… and I ain't bad."

— Paul Bryant after Alabama beat Ohio State in the '78 Sugar Bowl

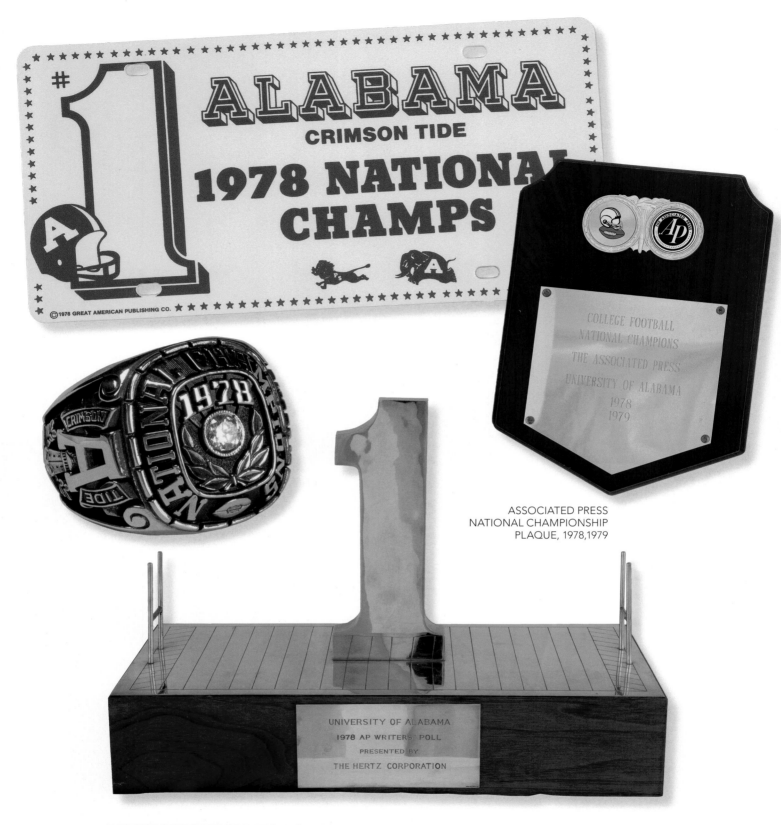

ASSOCIATED PRESS
NATIONAL CHAMPIONSHIP
PLAQUE, 1978,1979

## DISAPPOINTMENT INTO ACHIEVEMENT

After the disappointment of being overlooked for the 1977 national title, Coach Bryant and the Crimson Tide turned that negative energy into positive motivation for the 1978 season. Bama was going to need that motivation to get ready for the 1978 season and its cut-throat schedule. Alabama played five teams ranked in the top 10 including number 1 ranked Penn State in the 1979 Sugar Bowl. All-Americans Barry Krauss and Marty Lyons were just two of the heroes from the legendary goal line stand securing Coach Bryant's 5th National Championship.

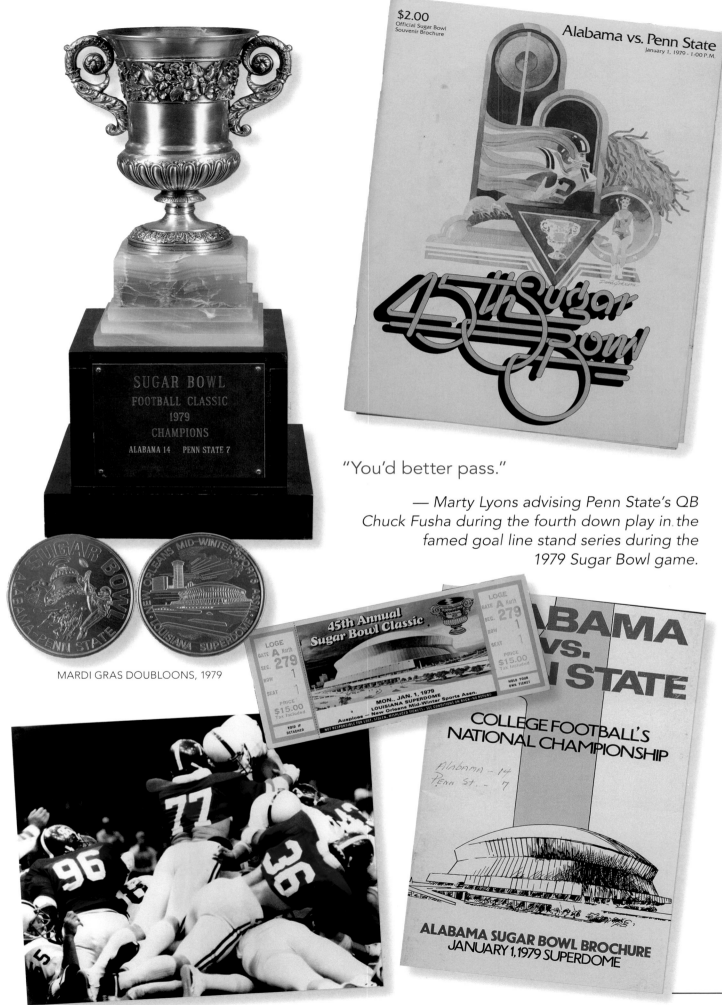

$2.00
Official Sugar Bowl
Souvenir Brochure

Alabama vs. Penn State
January 1, 1979 - 1:00 P.M.

45th Sugar Bowl

SUGAR BOWL
FOOTBALL CLASSIC
1979
CHAMPIONS
ALABAMA 14    PENN STATE 7

"You'd better pass."

— Marty Lyons advising Penn State's QB Chuck Fusha during the fourth down play in the famed goal line stand series during the 1979 Sugar Bowl game.

MARDI GRAS DOUBLOONS, 1979

45th Annual
Sugar Bowl Classic

MON., JAN. 1, 1979
LOUISIANA SUPERDOME
Auspices — New Orleans Mid-Winter Sports Assn.

LOGE
GATE A North
SEC. 279
ROW 1
SEAT 1
PRICE $15.00
Tax Included

ALABAMA
VS.
PENN STATE

COLLEGE FOOTBALL'S
NATIONAL CHAMPIONSHIP

Alabama - 14
Penn St. - 7

ALABAMA SUGAR BOWL BROCHURE
JANUARY 1, 1979 SUPERDOME

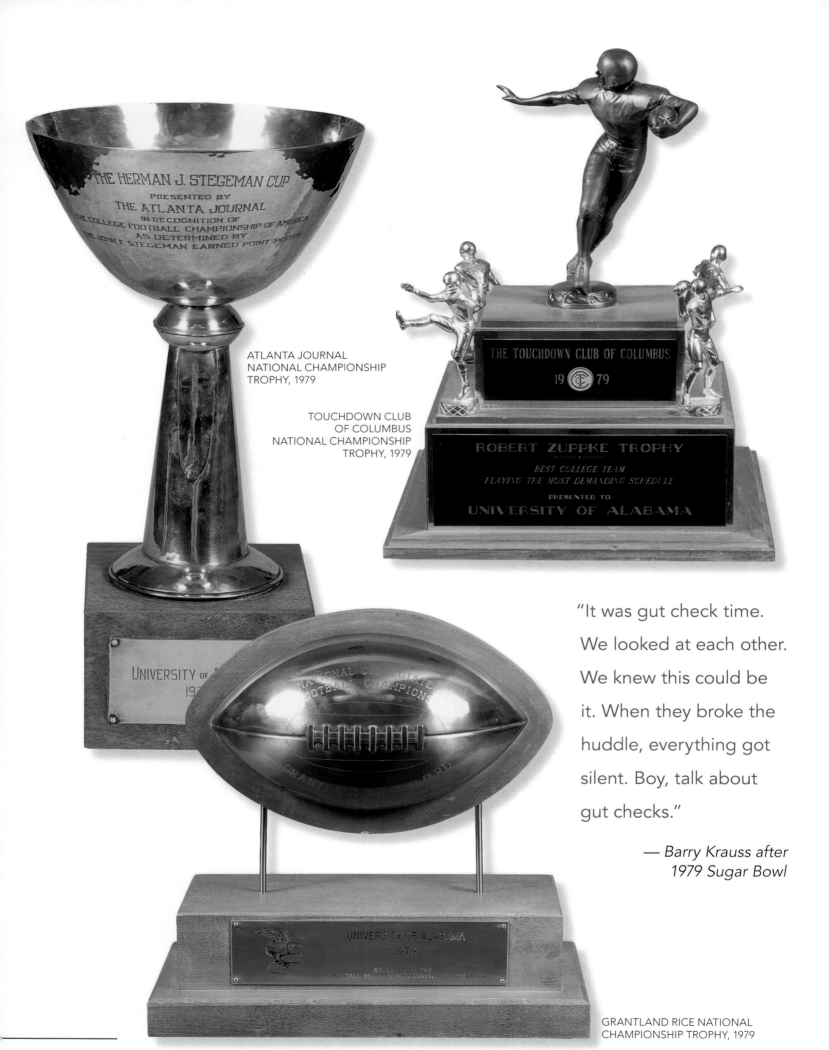

ATLANTA JOURNAL
NATIONAL CHAMPIONSHIP
TROPHY, 1979

TOUCHDOWN CLUB
OF COLUMBUS
NATIONAL CHAMPIONSHIP
TROPHY, 1979

"It was gut check time.
We looked at each other.
We knew this could be
it. When they broke the
huddle, everything got
silent. Boy, talk about
gut checks."

— *Barry Krauss after
1979 Sugar Bowl*

GRANTLAND RICE NATIONAL
CHAMPIONSHIP TROPHY, 1979

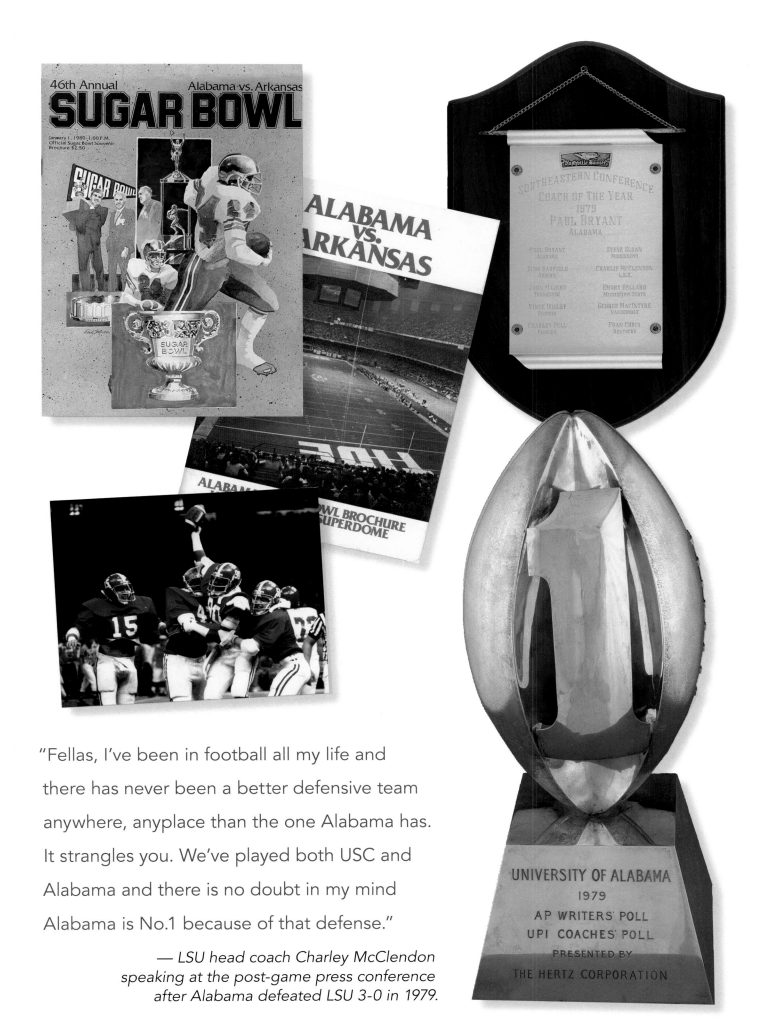

"Fellas, I've been in football all my life and there has never been a better defensive team anywhere, anyplace than the one Alabama has. It strangles you. We've played both USC and Alabama and there is no doubt in my mind Alabama is No.1 because of that defense."

*— LSU head coach Charley McClendon speaking at the post-game press conference after Alabama defeated LSU 3-0 in 1979.*

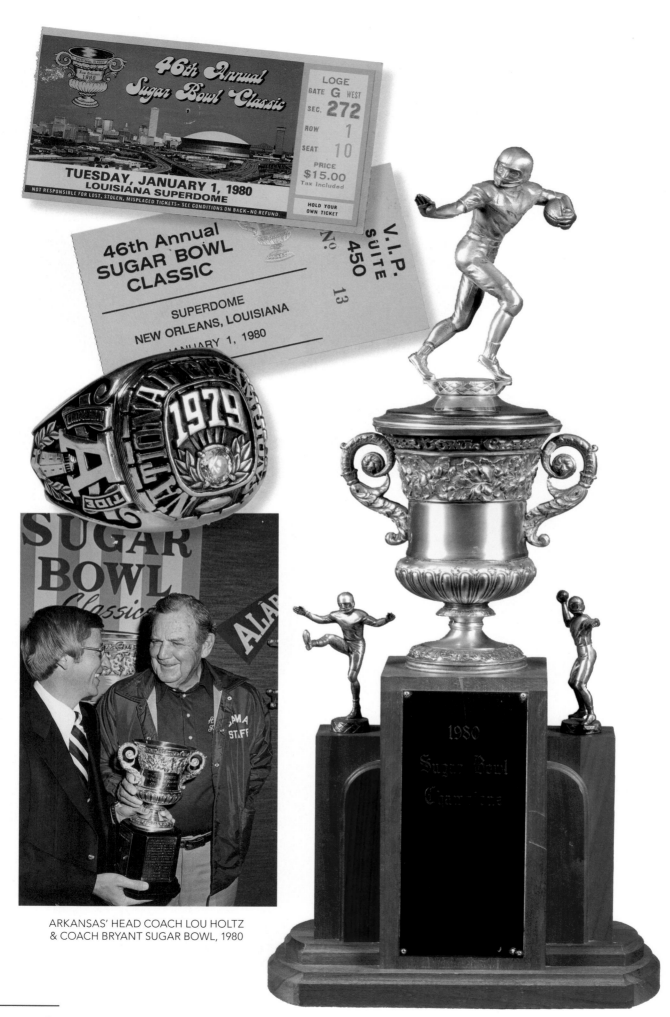

46th Annual
*Sugar Bowl Classic*

LOGE
GATE **G** WEST
SEC. **272**
ROW **1**
SEAT **10**
PRICE
**$15.00**
Tax Included

HOLD YOUR
OWN TICKET

TUESDAY, JANUARY 1, 1980
LOUISIANA SUPERDOME

NOT RESPONSIBLE FOR LOST, STOLEN, MISPLACED TICKETS • SEE CONDITIONS ON BACK • NO REFUND.

46th Annual
SUGAR BOWL
CLASSIC

V.I.P.
SUITE
450

SUPERDOME
NEW ORLEANS, LOUISIANA

JANUARY 1, 1980

**1979**

1980
*Sugar Bowl
Champions*

ARKANSAS' HEAD COACH LOU HOLTZ
& COACH BRYANT SUGAR BOWL, 1980

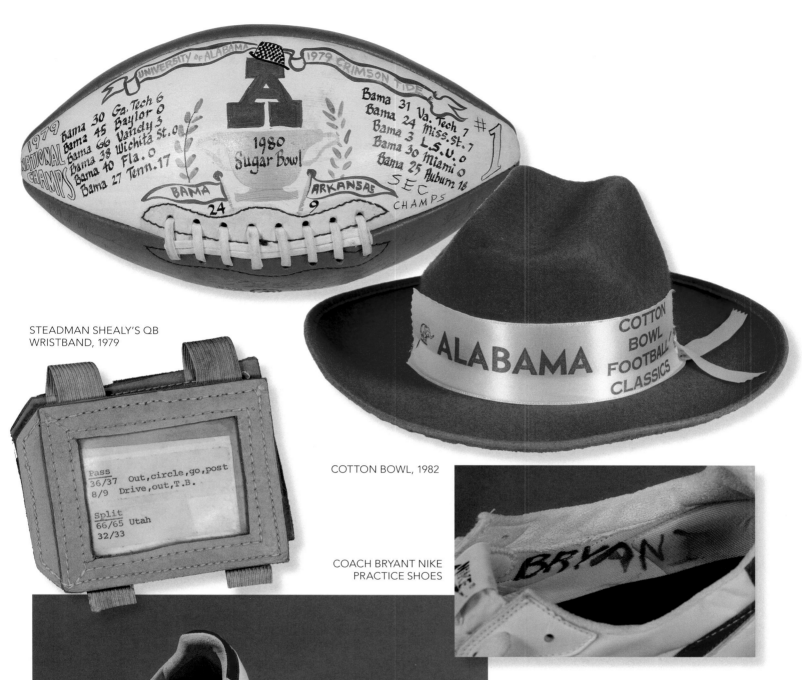

UNIVERSITY OF ALABAMA · 1979 CRIMSON TIDE

1979 NATIONAL CHAMPS

Bama 30 Ga. Tech 6
Bama 45 Baylor 0
Bama 66 Vandy 3
Bama 38 Wichita St. 0
Bama 40 Fla. 0
Bama 27 Tenn. 17

1980 Sugar Bowl

BAMA 24    ARKANSAS 9

Bama 31 Va. Tech 7
Bama 24 Miss. St. 7
Bama 3 L.S.U. 0
Bama 30 Miami 0
Bama 25 Auburn 18

#1

SEC CHAMPS

STEADMAN SHEALY'S QB
WRISTBAND, 1979

Pass
36/37  Out, circle, go, post
8/9    Drive, out, T.B.

Split
66/65  Utah
32/33

ALABAMA COTTON BOWL FOOTBALL CLASSICS

COTTON BOWL, 1982

COACH BRYANT NIKE
PRACTICE SHOES

BRYANT

"I tell my players they're special. They're something everybody should be proud of. They're not like the other students. I say, If you were we'd have fifteen thousand out for football. You've got to take pride in being something special."

— *Paul Bryant*

# THE RECORD

## 1980–1983

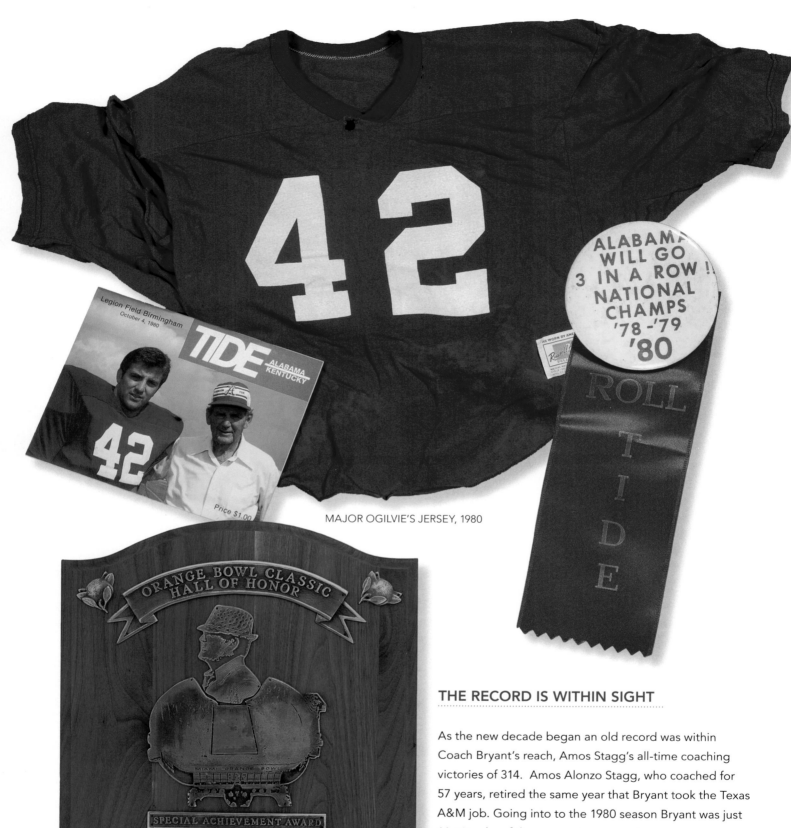

MAJOR OGILVIE'S JERSEY, 1980

ALABAMA WILL GO 3 IN A ROW !! NATIONAL CHAMPS '78-'79 '80

ROLL TIDE

ORANGE BOWL CLASSIC HALL OF HONOR

SPECIAL ACHIEVEMENT AWARD

IN TRIBUTE TO
PAUL W. "BEAR" BRYANT
UNIVERSITY OF ALABAMA
UPON HIS 300th INTERCOLLEGIATE
FOOTBALL VICTORY
ALABAMA 45, KENTUCKY 0
OCT. 4, 1980
BIRMINGHAM, ALABAMA

PRESIDENT

Legion Field Birmingham
October 4, 1980

TIDE
ALABAMA
KENTUCKY

Price $1.00

## THE RECORD IS WITHIN SIGHT

As the new decade began an old record was within Coach Bryant's reach, Amos Stagg's all-time coaching victories of 314. Amos Alonzo Stagg, who coached for 57 years, retired the same year that Bryant took the Texas A&M job. Going into to the 1980 season Bryant was just 16 wins shy of the momentous record.

Bryant's quest for the record had been whispered about ever since he secured win number 250 against LSU in 1975. With the help of University of Alabama Sports Information Director Charley Thornton advertising to the world, the whispers became shouts. First the regional press started discussing it, and then the national press jumped on board.

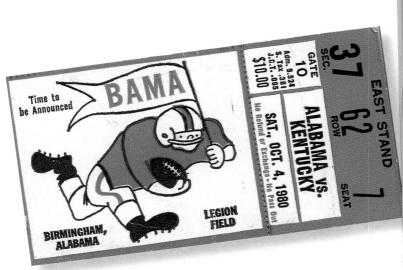

As Bryant was closing in on his 300th victory, "315 fever" was taking over the state of Alabama. As was his custom, Bryant, was worried the emphasis on him would take away from his players. In response Coach Bryant started his own publicity campaign, to make sure everyone understood that the players were just as important in this chase for the record as the head coach.

BEAR

NATIONAL CHAMPIONS
★ 1961 - ALABAMA
★ 1964 - ALABAMA
★ 1965 - ALABAMA
★ 1973 - ALABAMA
★ 1978 - ALABAMA
★ 1979 - ALABAMA

SEC CHAMPIONS
★ 1950 - Kentucky
★ 1961 - Alabama,
1964 - Alabama, 1965 - Alabama,
1966 - Alabama, 1972 - Alabama,
1973 - Alabama, 1974 - Alabama,
1975 - Alabama, 1977 - Alabama,
1978 - Alabama, 1979 - Alabama

SWC CHAMPION
★ 1956 - Texas A & M

PAUL W. BRYANT • HEAD COACH

Great Pair Says The "Bear"

GOLDEN FLAKE

"Winning isn't everything, but it sure beats anything that comes in second."
Paul W. Bryant

LIMITED EDITION
1981 COMMEMORATIVE CANISTER

UNIVERSITY OF ALABAMA

I WAS THERE! NO. 300 FOR THE BEAR!

The Man . . .

The nation watches as University of Alabama head coach Paul William "Bear" Bryant nears the all-time record for college football victories.

During his 35-year head coaching career, Coach Bryant has been selected National Coach of the Year three times and SEC Coach of the Year seven times. The NCAA picked him as the Coach of the Decade for the 1960's and he was honored as the SEC Coach of the Century.

Born September 11, 1913 near Fordyce, Arkansas in the hamlet of Moro Bottom, Bryant came from a family of 12 children. He played tackle for the Fordyce High School Redbugs and because of his size and aggressiveness was recruited to play for the University of Alabama.

At Alabama, Bryant became "the other end" because the great Don Hutson was a member of his three Alabama teams that went 23-3-2.

A 1936 graduate of Alabama, Bryant served four years as a Tide assistant, then went to Vanderbilt as an assistant for two years.

After the 1941 season Bryant volunteered for duty with the U.S. Navy. He was discharged in time to take the head coaching job at Maryland in 1945. In his first season, the Terrapins went 6-2-1. He left for the University of Kentucky where in eight seasons his teams went 60-23-5, won the only SEC title in Wildcat history and played in four post-season bowls.

In 1954, Bryant moved to Texas A & M. In his first season as the Aggies head coach, Bryant experienced the only losing season of his career. In the following three seasons, however, the Aggies had a record of 24-9-2, won a Southwest Conference championship, and produced a Heisman Trophy winner in John David Crow.

Coach Bryant's alma mater called in 1958. In addition to his 215-40-8 record in 22 years under Bryant, the Crimson Tide has won a dozen SEC titles. 42 of his former players or assistant coaches have become head coaches in college or professional football.

During each season as head coach at Alabama, Coach Bryant has narrated each game's play-by-play on "The Bear Bryant Show," one of the most popular collegiate coaching shows in the nation. Golden Flake Snack Foods, Inc., has sponsored the show since 1960.

Coach Bryant is married to the former Mary Harmon Black, and they are the parents of two children—Paul Bryant, Jr., and Mrs. John (Mae Martin) Tyson, III. Coach and Mrs. Bryant have five grandchildren.

OCTOBER 4 · 1980

ALABAMA 45 KENTUCKY 0
300TH WIN for
Coach Paul "Bear" Bryant

DonBarnes

GAME USED BALL,
ARTIST DON BARNES, 1980

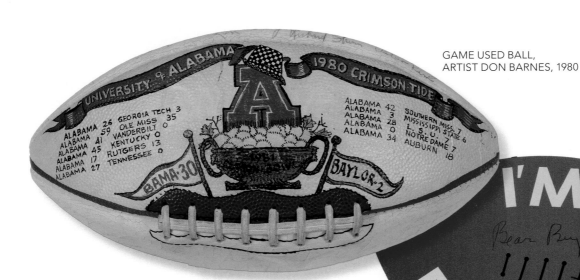

GAME USED BALL,
ARTIST DON BARNES, 1980

"He can take his'n and beat your'n —

or he can take your'n and beat his'n"

— *Florida A&M head coach*
*Alonzo "Jake" Gaither referring to Bryant*

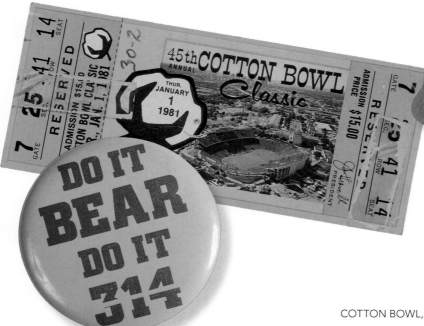

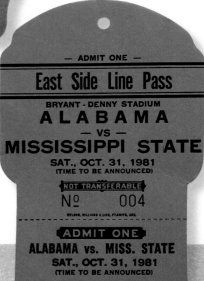

COTTON BOWL, 1982

WERE YOU THERE?
ALA. 13 STATE 10

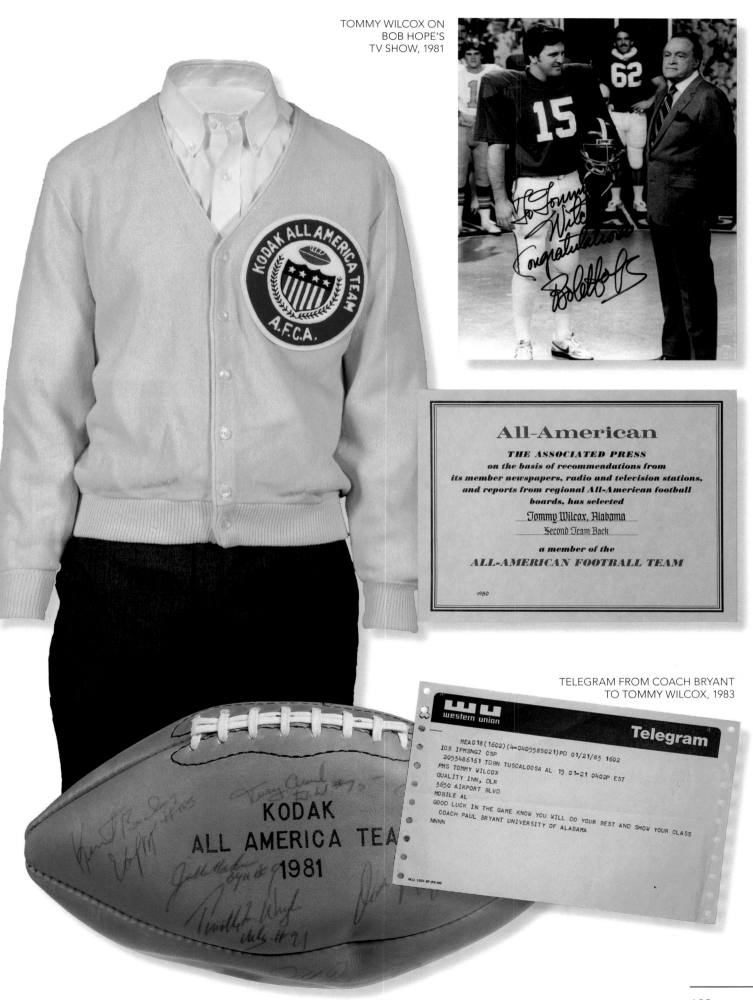

KODAK ALL AMERICA TEAM
A.F.C.A.

## All-American

**THE ASSOCIATED PRESS**
*on the basis of recommendations from*
*its member newspapers, radio and television stations,*
*and reports from regional All-American football*
*boards, has selected*

Tommy Wilcox, Alabama

Second Team Back

*a member of the*

***ALL-AMERICAN FOOTBALL TEAM***

1980

TELEGRAM FROM COACH BRYANT
TO TOMMY WILCOX, 1983

western union — Telegram

MEA018(1602)(4-040558S021)PD 01/21/83 1602
ICS IPMBNGZ CSP
2053486161 TDBN TUSCALOOSA AL 15 01-21 0402P EST
PMS TOMMY WILCOX
QUALITY INN, DLR
3650 AIRPORT BLVD
MOBILE AL
GOOD LUCK IN THE GAME KNOW YOU WILL DO YOUR BEST AND SHOW YOUR CLASS
COACH PAUL BRYANT UNIVERSITY OF ALABAMA
NNNN

W.U. 1201-SF (R5-69)

KODAK
ALL AMERICA TEAM
1981

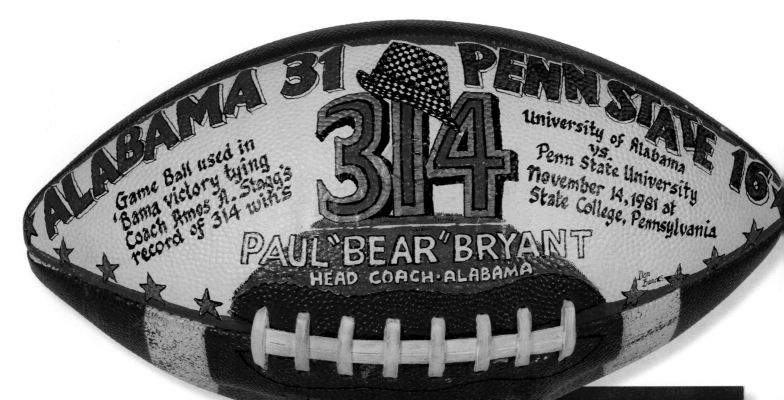

ALABAMA 31 • PENN STATE 16

314

Game Ball used in 'Bama victory tying Coach Amos A. Stagg's record of 314 wins

University of Alabama vs. Penn State University November 14, 1981 at State College, Pennsylvania

PAUL "BEAR" BRYANT
HEAD COACH • ALABAMA

Don Barnes

UNIVERSITY OF ALABAMA
MEDIA GUIDE, 1981

"You can learn a lot on
the football field that isn't
taught in the home,
in the church, or in the
classroom. I'm a pretty
good example of that."

— *Paul Bryant*

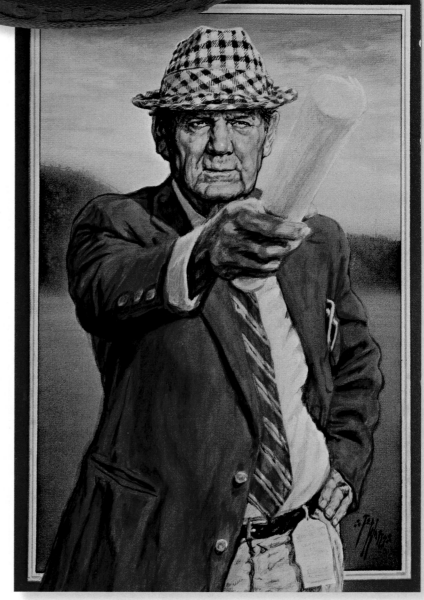

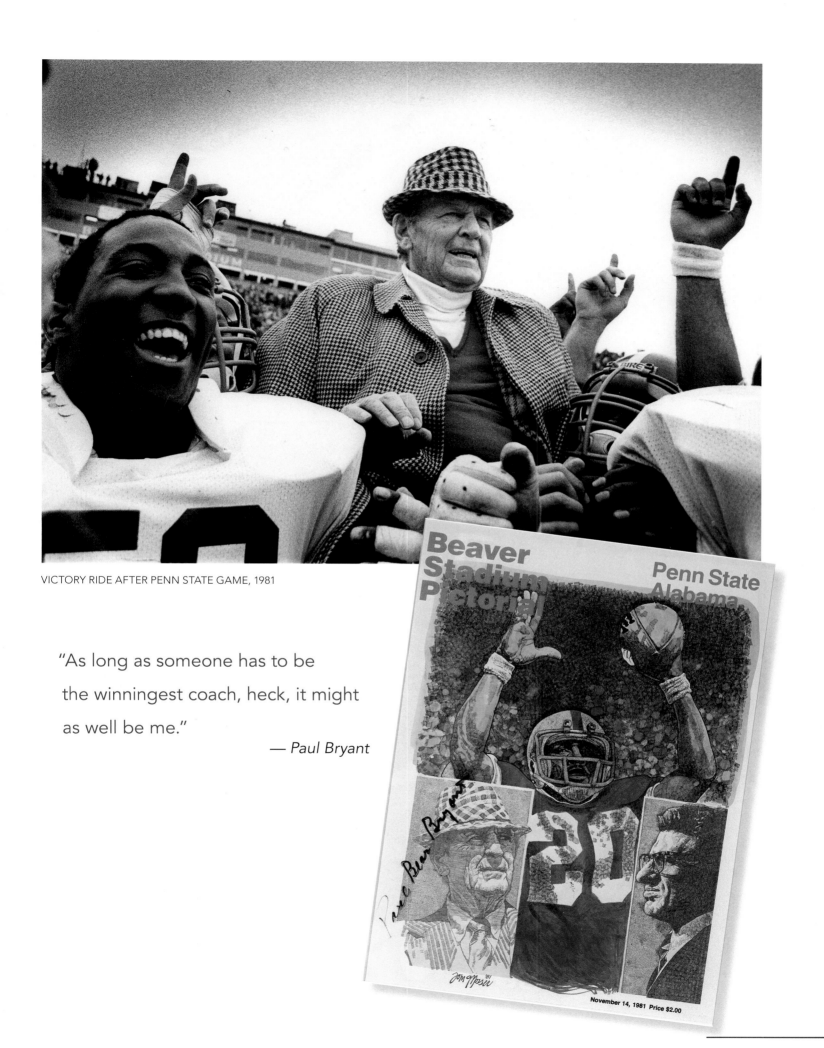

VICTORY RIDE AFTER PENN STATE GAME, 1981

"As long as someone has to be the winningest coach, heck, it might as well be me."

— *Paul Bryant*

Beaver Stadium Pictorial

Penn State Alabama

November 14, 1981 Price $2.00

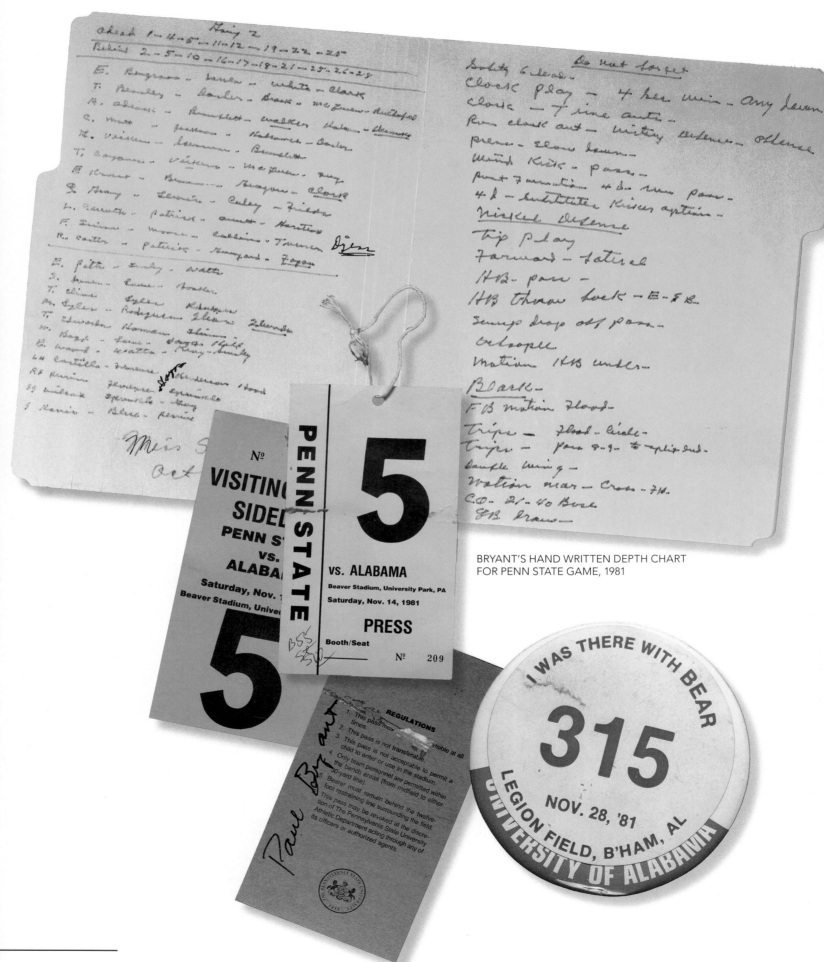

BRYANT'S HAND WRITTEN DEPTH CHART
FOR PENN STATE GAME, 1981

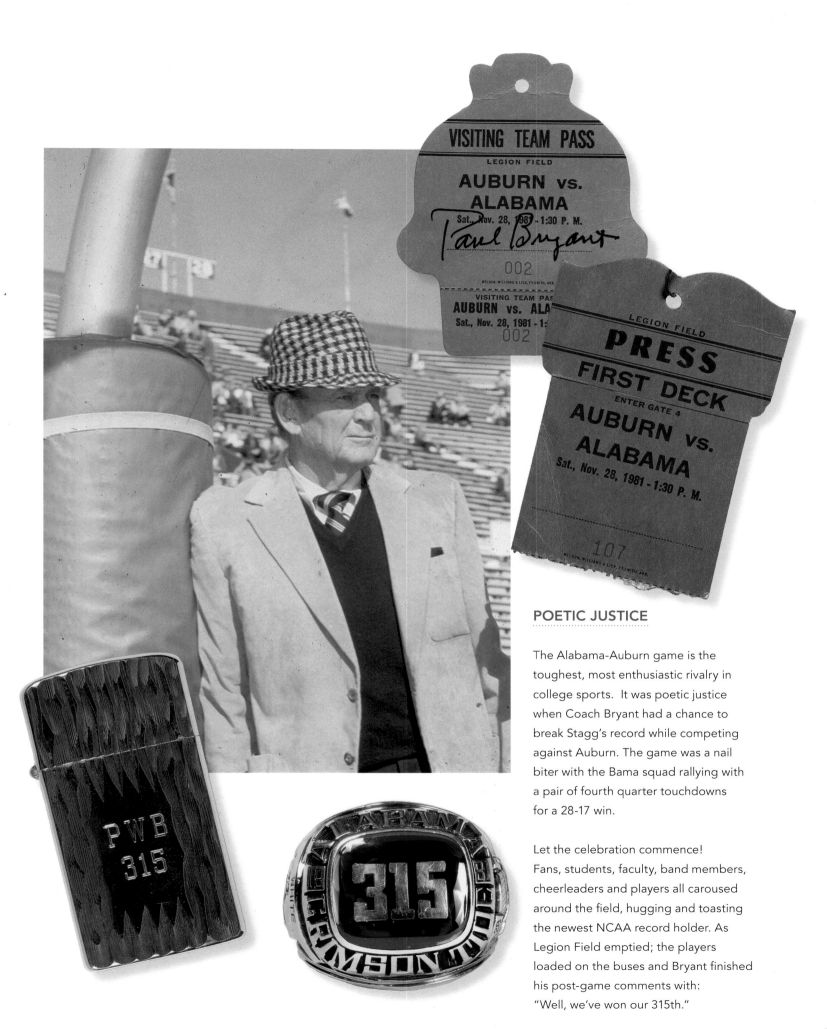

VISITING TEAM PASS

LEGION FIELD

AUBURN vs. ALABAMA

Sat., Nov. 28, 1981 - 1:30 P. M.

*Paul Bryant*

002

WELDON, WILLIAMS & LICK, FT. SMITH, ARK.

VISITING TEAM PASS

AUBURN vs. ALA

Sat., Nov. 28, 1981 - 1:

002

LEGION FIELD

PRESS

FIRST DECK

ENTER GATE 4

AUBURN vs. ALABAMA

Sat., Nov. 28, 1981 - 1:30 P. M.

107

WELDON, WILLIAMS & LICK, FT. SMITH, ARK.

PWB 315

315

ALABAMA

CRIMSON

## POETIC JUSTICE

The Alabama-Auburn game is the toughest, most enthusiastic rivalry in college sports. It was poetic justice when Coach Bryant had a chance to break Stagg's record while competing against Auburn. The game was a nail biter with the Bama squad rallying with a pair of fourth quarter touchdowns for a 28-17 win.

Let the celebration commence! Fans, students, faculty, band members, cheerleaders and players all caroused around the field, hugging and toasting the newest NCAA record holder. As Legion Field emptied; the players loaded on the buses and Bryant finished his post-game comments with: "Well, we've won our 315th."

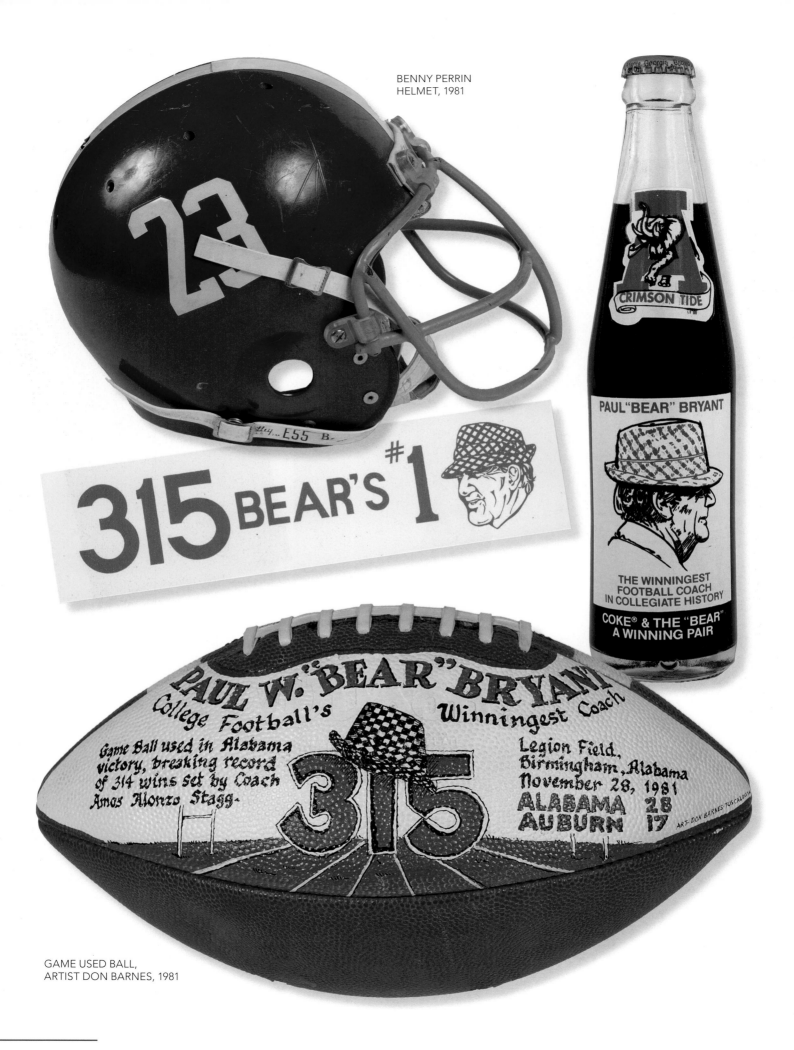

BENNY PERRIN
HELMET, 1981

GAME USED BALL,
ARTIST DON BARNES, 1981

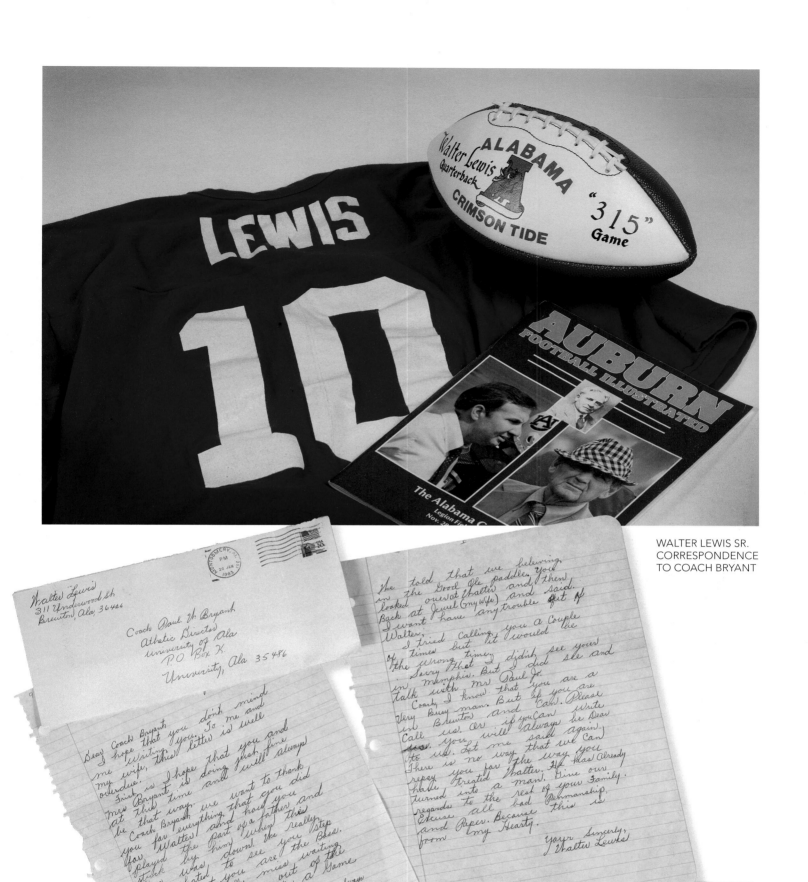

WALTER LEWIS SR.
CORRESPONDENCE
TO COACH BRYANT

**I WAS THERE**
LEGION FIELD - BIRMINGHAM, ALABAMA - NOV. 28, 1981
**Bama 28/Auburn 17**
**WIN #315**

$2.00 each - send cash, check or money order to Honest Abe Enterprises, P.O. Box 139, Birmingham, AL 35061-0139

"I wish I could tell you how proud I am to be an Alabama football player. But I have no idea how to do it. I feel as rich as Howard Hughes. I feel like I share that pedestal Coach Bryant stands on tonight."

— *Warren Lyles*

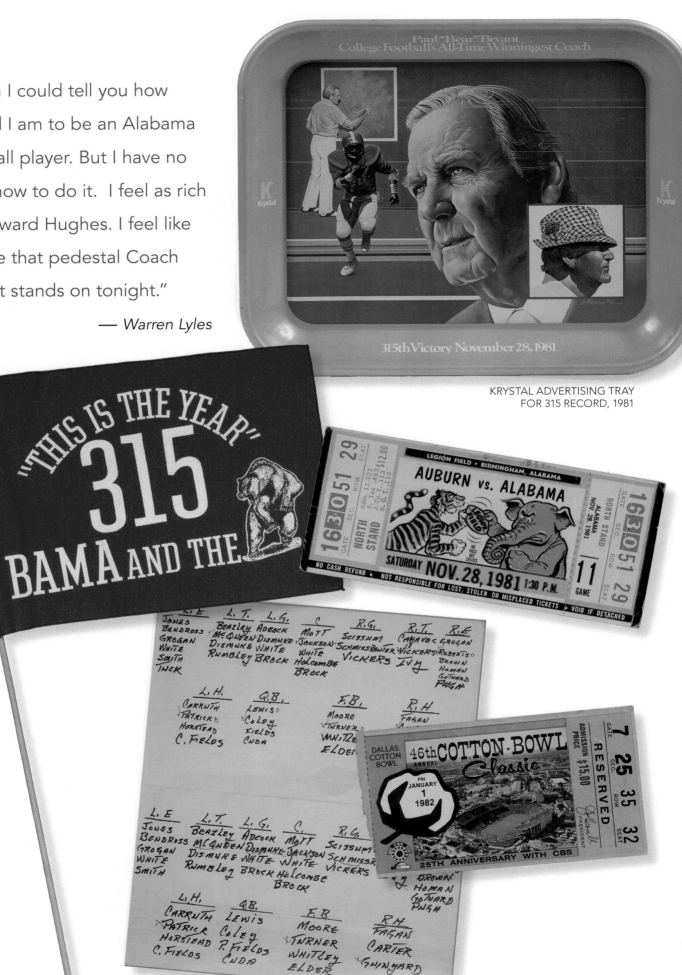

KRYSTAL ADVERTISING TRAY
FOR 315 RECORD, 1981

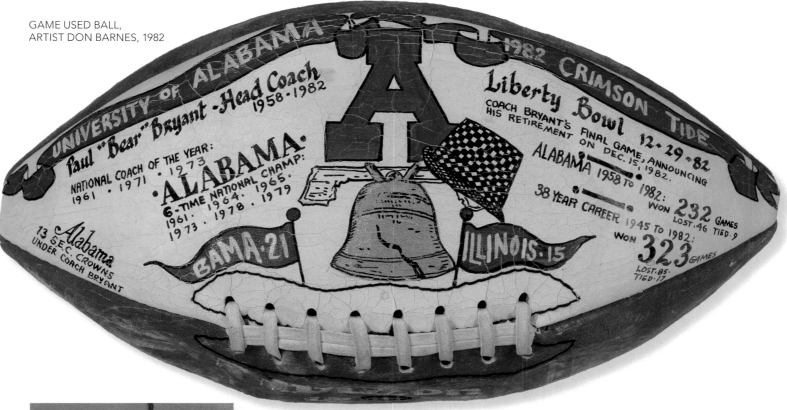

GAME USED BALL,
ARTIST DON BARNES, 1982

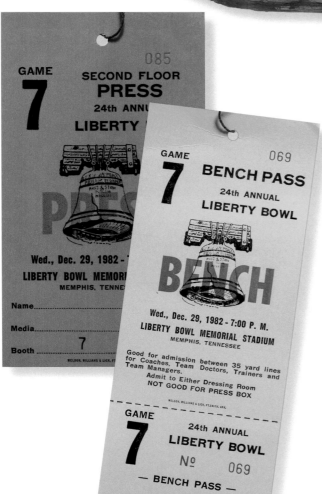

## THE COACH, THE MAN, THE LEGEND

Paul William Bryant lived the American dream. He started out from hard times, and through hard work made it to the top of his profession. He won more games, more national championships than any other coach in the history of the game. He met with presidents of the United States, he played golf with the world's biggest celebrities, and he ate dinner with the parents of recruits. To those recruits turned players; he became like a tough old fashioned father. The players loved him, but they never forgot who was in charge. They never forgot how much he expected of them, and even when they thought his expectations were too high, they tried to meet those goals. Bryant was a great coach, and even after his record was eclipsed he will still be considered one of the game's greatest coaches. Not only for his on the field achievements but for the lessons he taught his players. We all know Paul Bryant was a great coach, but more importantly he was a great man.

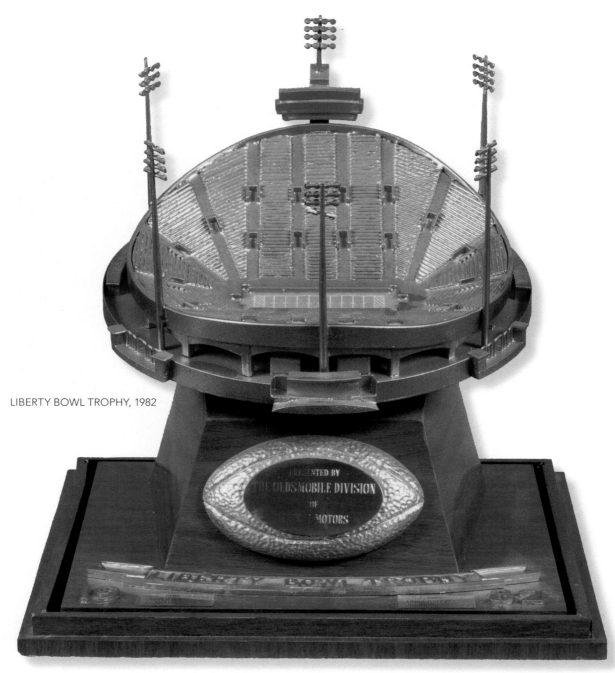

LIBERTY BOWL TROPHY, 1982

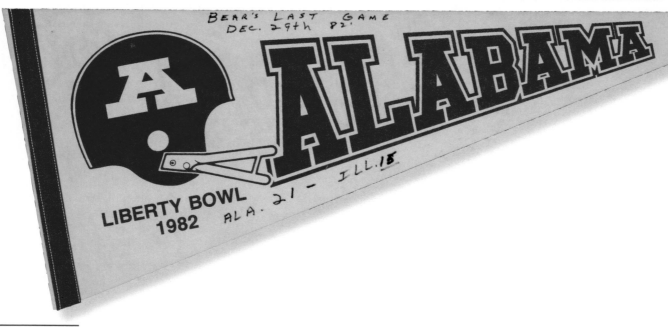

# I SAW
# BEAR'S LAST GAME
## Alabama vs Illinois
Dec. 29, 1982     Memphis, TN

SEC. WEST SIDE
ROW 7 SEAT 35
H
GATE 4
No Refund or Exchange
NO PASS OUT
Hold Your Own Ticket
PRICE $16.00

24th ANNUAL Wed., Dec. 29, 1982
LIBERTY BOWL
LIBERTY BOWL MEMORIAL STADIUM

## ALABAMA VS. ILLINOIS

### ALABAMA LIBERTY BOWL BROCHURE
### DECEMBER 29, 1982 - 7:00 P.M. - MEMPHIS

"I've done a poor job of coaching. This is my school, my alma mater and I love it. And I love the players, but in my opinion they deserve better coaching than they have been getting from me this year and my stepping down is an effort to see that they get better coaching from somebody else."

— *Paul Bryant,*
*December 15, 1982*

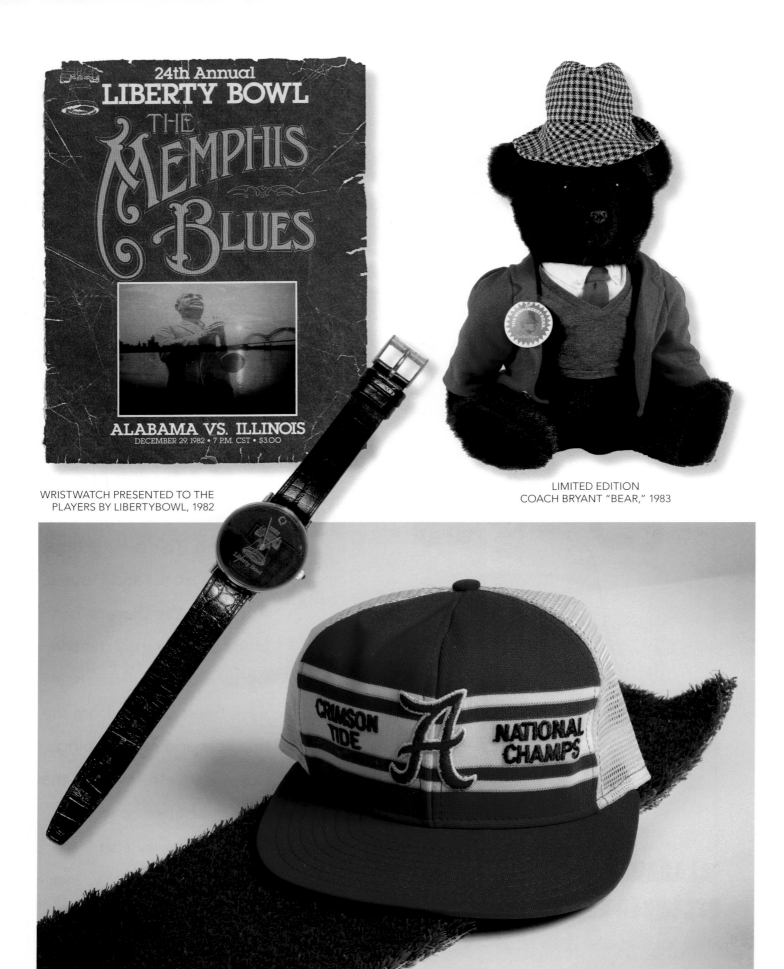

WRISTWATCH PRESENTED TO THE
PLAYERS BY LIBERTYBOWL, 1982

LIMITED EDITION
COACH BRYANT "BEAR," 1983

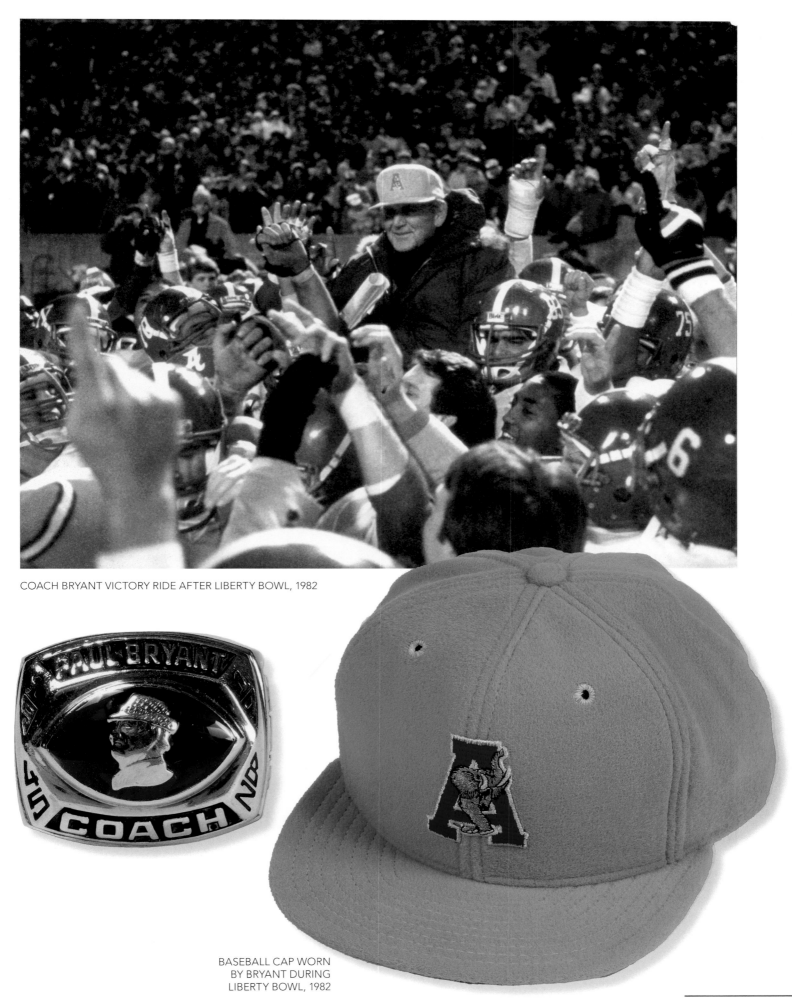

COACH BRYANT VICTORY RIDE AFTER LIBERTY BOWL, 1982

BASEBALL CAP WORN
BY BRYANT DURING
LIBERTY BOWL, 1982

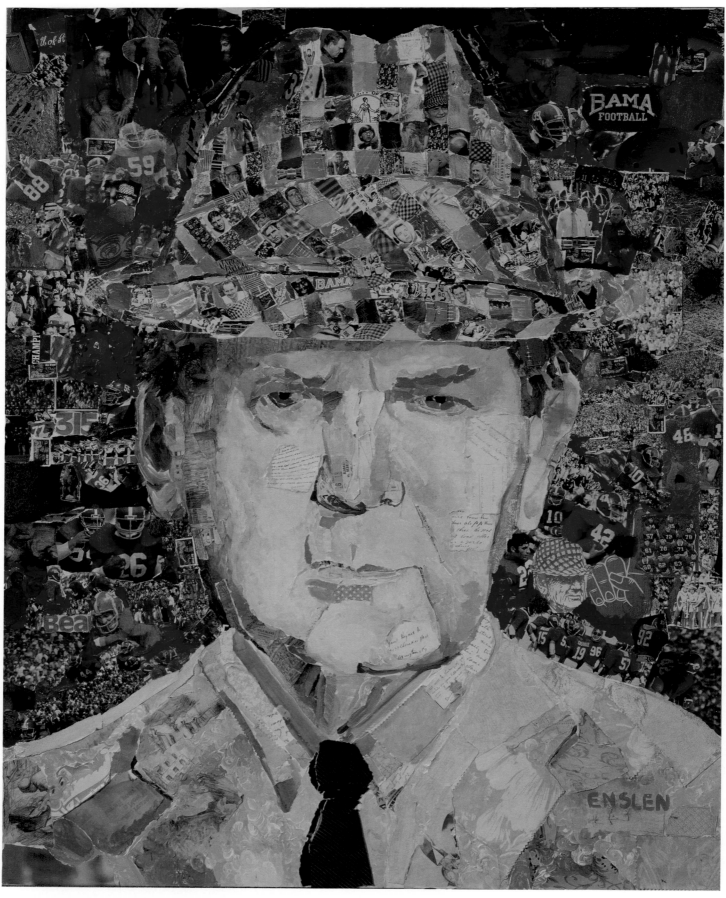

MIXED MEDIA PAINTING BY ALAINA ENSLEN

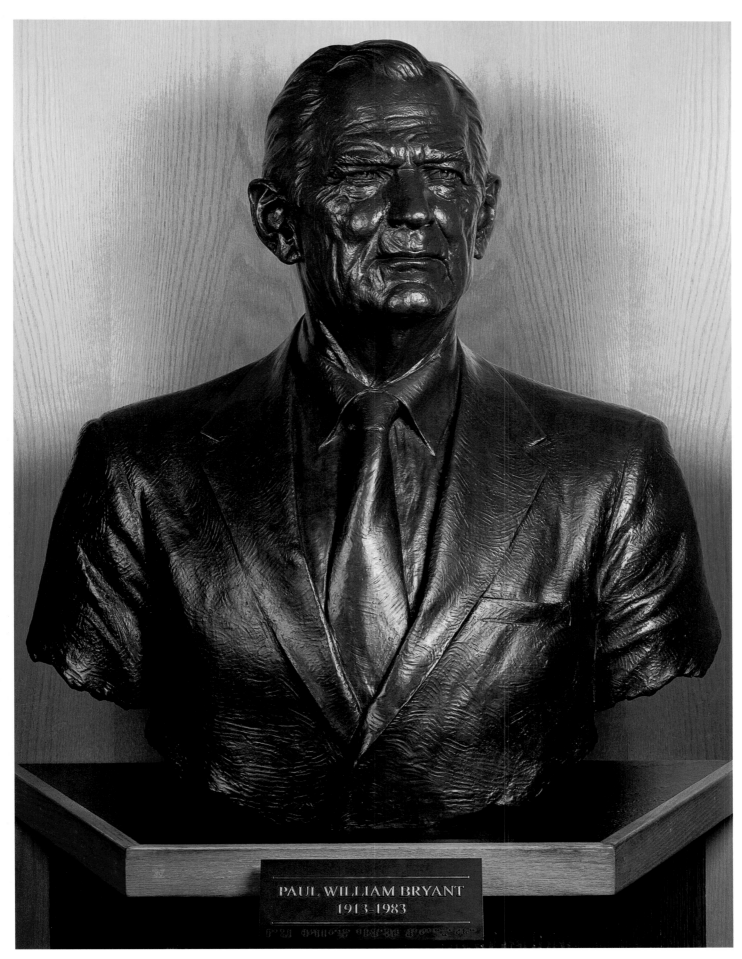

PAUL WILLIAM BRYANT
1913-1983

UNIVERSITY OF ALABAMA COMMISSIONED BUST OF COACH BRYANT
BY ARTIST BLAIR BUSWELL

"Today we Americans lost a hero who always seemed larger than life. Paul "Bear" Bryant won more college football games than any coach in history and he made legends out of ordinary people. Only four weeks ago we held our breath and cheered when the Bear notched his final victory in a game named, fittingly, the Liberty Bowl.

"Paul Bryant was a hard, but loved taskmaster, patriotic to the core, devoted to his players and inspired by a winning spirit that would not quit. Bear Bryant gave his country the gift of a life unsurpassed. In making the impossible seem easy, he lived what we strive to be."

— *President Ronald Reagan, January 26, 1983*

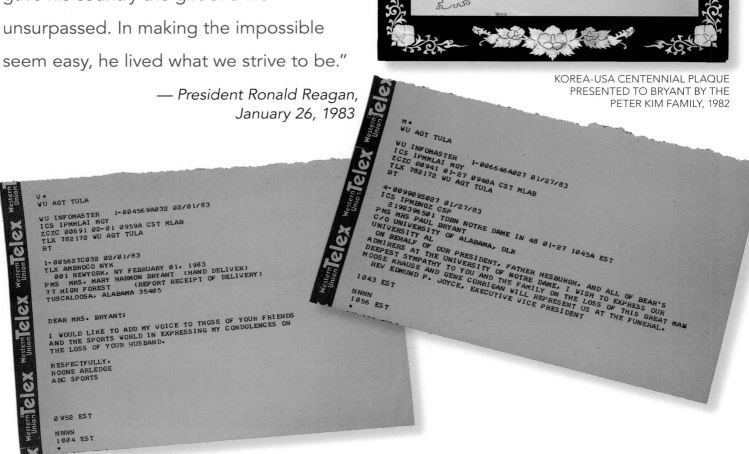

KOREA-USA CENTENNIAL PLAQUE
PRESENTED TO BRYANT BY THE
PETER KIM FAMILY, 1982

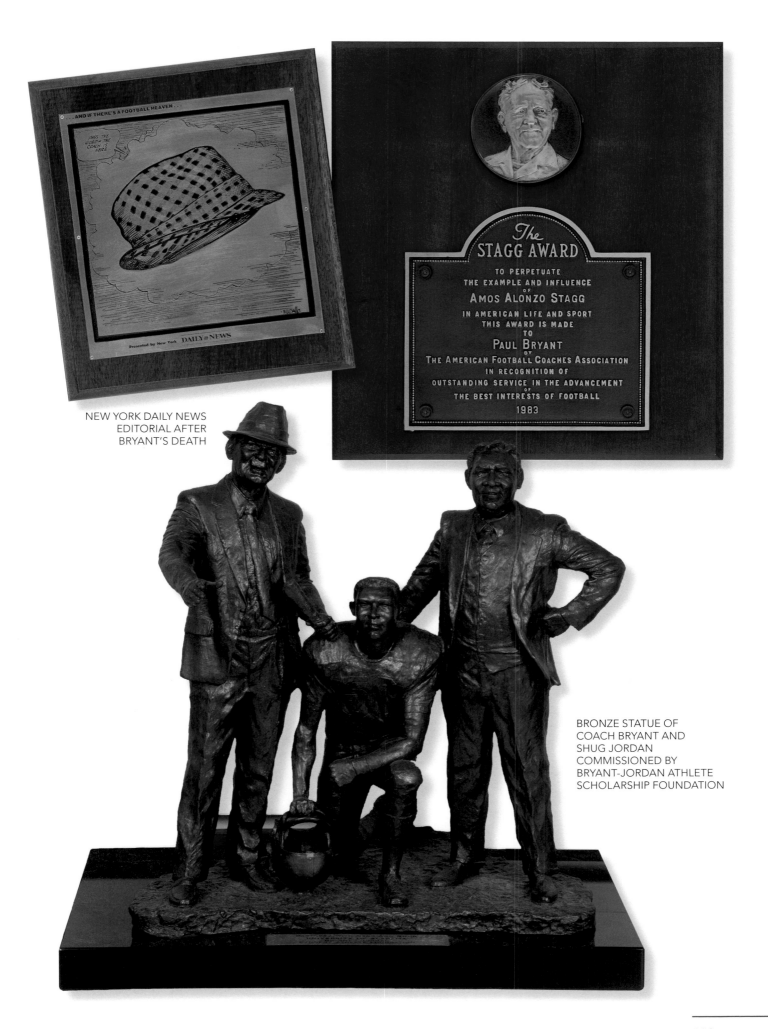

...AND IF THERE'S A FOOTBALL HEAVEN...

PASS THE WORD THE COACH IS HERE

Presented by New York DAILY NEWS

The STAGG AWARD

TO PERPETUATE
THE EXAMPLE AND INFLUENCE
OF
AMOS ALONZO STAGG
IN AMERICAN LIFE AND SPORT
THIS AWARD IS MADE
TO
Paul Bryant
BY
THE AMERICAN FOOTBALL COACHES ASSOCIATION
IN RECOGNITION OF
OUTSTANDING SERVICE IN THE ADVANCEMENT
OF
THE BEST INTERESTS OF FOOTBALL
1983

NEW YORK DAILY NEWS
EDITORIAL AFTER
BRYANT'S DEATH

BRONZE STATUE OF
COACH BRYANT AND
SHUG JORDAN
COMMISSIONED BY
BRYANT-JORDAN ATHLETE
SCHOLARSHIP FOUNDATION

ALABAMA — ROLL TIDE!

Alabama senior standouts pose with Coach Paul "Bear" Bryant. From left, Tommy Wilcox, Robbie Jones, Mike Pitts, Coach Bryant, Steve Mott and Jackie Cline.

COACH BRYANT'S HANDWRITTEN NOTES
FOR A SPEECH, JANUARY 1983

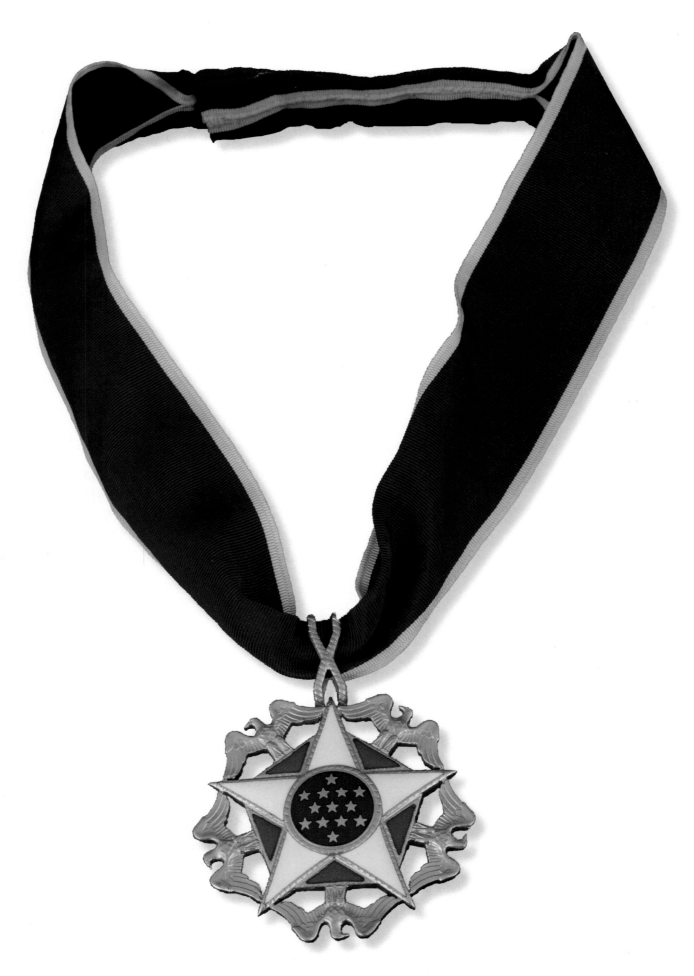

PRESIDENTIAL MEDAL OF FREEDOM, FEBRUARY 1983

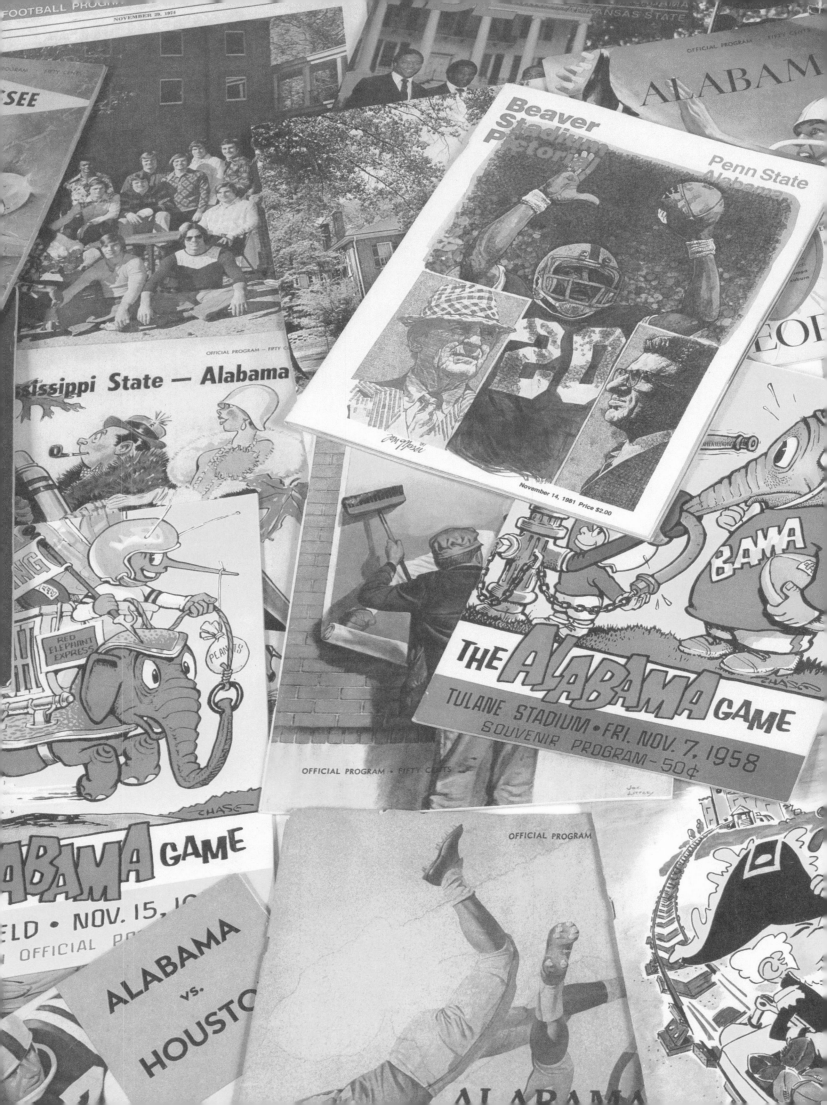